ASBURY PARK

ASBURY PARK

A BRIEF HISTORY

Joesph G. Bilby & Harry Ziegler

Charleston · London

THE
History
PRESS

Published by The History Press
Charleston, SC 29403
www.historypress.net

First published 2009

Manufactured in the United States

ISBN 978.1.59629.604.6

Library of Congress Cataloging-in-Publication Data

Bilby, Joseph G.
Asbury Park, New Jersey : a brief history / Joseph G. Bilby and Harry F. Ziegler.
p. cm.
Includes bibliographical references.
ISBN 978-1-59629-604-6
1. Asbury Park (N.J.)--History. 2. Asbury Park (N.J.)--Social life and customs. 3. Asbury Park (N.J.)--Social conditions. 4. Asbury Park (N.J.)--Economic conditions. 5. Seaside resorts--New Jersey--Asbury Park--History. 6. Amusements--New Jersey--Asbury Park--History. I. Ziegler, Harry F. II. Title.
F144.A6B55 2009
974.9'46--dc22

2008047473

Dedicated to the memory of Harry and Lydia Whelan,
Asbury Parkers of the 1950s.

CONTENTS

CONTENTS

PREFACE

Every town and city has its stories, and New Jersey's municipalities seem to have more than their share, featuring outsized characters and memorable incidents in both fact and fiction. The tale of Asbury Park has to rank near the top of those Garden State sagas. From the grandiose yet erratic James A. Bradley, who came to a barren Monmouth County beach with plans for a new Promised Land, to Mayor Clarence Hetrick, a blend of Jay Gatsby and legendary political boss Frank Hague of Jersey City, to Bruce Springsteen, whose song stories have made the town the stuff of legend itself, to a bewildered Tony Soprano, twisting in a tumbledown boardwalk dream of horror, Asbury Park has burned itself into the local, state and national consciousness.

Asbury Park has figured in the lives of the authors for generations. Harry Ziegler, born and bred at the Jersey Shore, has seen Asbury in good days and in bad, from bargain shopping as a child with his grandmother on Springwood Avenue to his days as reporter, bureau chief and managing editor of the *Asbury Park Press*, the city's paper of record and New Jersey's second-largest periodical. Joseph Bilby, a Newark native and New Jersey historian whose work has until recently been largely centered on the state's role in the Civil War, has a more casual, but still intense, relationship with Asbury Park—from childhood memories of boardwalk adventures to the time when, just returned from serving as an army lieutenant in Vietnam, he hit the sidewalk across the street from Steinbach's department store as a car backfired.

The story of Asbury Park is the tale of a unique and diverse city in a unique and diverse state, often overlooked in the grand scheme of American historiography. It rose, fell and is rising yet again. Come along for the ride.

ACKNOWLEDGEMENTS

Librarians are a writer's best friend. No one can write a book on Asbury Park without visiting the helpful folks at the Asbury Park Library. Librarian Robert W. Stewart and library webmaster Malakia A. Oglesby supplied invaluable assistance, guidance and direction, as well as some excellent illustrations. Sea Girt librarian Anne Ryan, who shared her collection of old Asbury Park photographs, also provided invaluable assistance. Others who contributed valuable material to this work include Bernard Bush, Bob Hopkins, Bob Pontecorvo, Jerry Travers, Steve Garratano, James Kaufmann, Jim Madden, Michelle Nice, Don Stine and Bill Styple. Any errors, of course, are solely the responsibility of the authors.

JAMES A. BRADLEY, THE FOUNDER

A MAN OF HIS TIMES

He died on June 21, 1921, having long outlived his time. It didn't take long for them to put up a statue of him looking out at the sea, "pledged in appreciation of a great man's work," or for people walking by, within a few years, to look at the statue and ask one another, "Who's that?" Eventually, they built Convention Hall in front of him, blocking his sightless eyes' view of the ocean that had brought him here in the first place. He stood there through the 1980s, when you could find a parking space right by the beach on the hottest day in July, most people agreed the city's best days were gone, likely to never return, and the passing clientele of a corner bar were his only company. One wag climbed up and stuck a beer bottle in the crook of his arm. It was the nadir. Times had to get better, thought the few optimists, whose numbers diminished by the day. It took a while, but they did. He stands there today in those better times. Whether "the Founder" would be happy or not in a world now far beyond his understanding is, however, a question that shall remain forever unanswered.[1]

In nearby Bradley Beach, a town named after the Founder about a mile or so to the south, there is a store called Bradley Liquors. If people do indeed spin in graves, the old Methodist prohibitionist James Adam Bradley is no doubt rotating rapidly. It is safe to say that Asbury Park, his first creation, did not turn out the way that Bradley hoped it would, but the little New Jersey Shore city's struggles between the sacred and profane and the sophisticated and the crass—all the while riding a roller coaster of economic and political ups and downs for almost a century and a half—give rise to stories both delightful and dark, peopled by a cast of characters worthy of any novel.

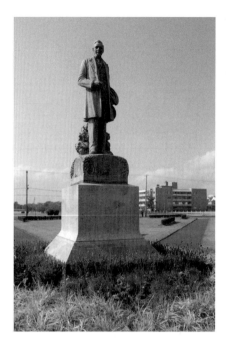

The Bradley Statue, erected in 1921, still stands in a park between the Berkeley-Carteret Hotel and the Wonder Bar, both beyond his nineteenth-century imagination. *Courtesy Joseph Bilby.*

Over the years, Bradley has been characterized variously as a benevolent and forward-looking patron or a narrow-minded reactionary. As with most things, the truth is more nuanced. James Bradley was a complex man. He was born in a tavern called the Old Blazing Star Inn in the Staten Island community of Rossville on February 14, 1830, to Adam Bradley, an Irish-born Catholic farmer, and his English immigrant Protestant wife, Hannah. Following the death of his father, apparently of alcoholism, when Bradley was four, Hannah married a man named Charles Smith. Two years later, the Smith family moved to lower Manhattan, where they resettled on Cherry Street and opened a "second hand store" retailing other peoples' hand-me-downs. Although assigned his stepfather's last name for a while, young James eventually rejected it and became "Jim" Bradley once more.[2]

Jim Bradley grew into adolescence on the streets of lower Manhattan. Following a minimal public school education, he worked for a while in a brass foundry before being apprenticed at age fourteen to a Bloomfield, New Jersey farmer and friend of the Smiths, allegedly to remove him from the influence of the young street toughs known as "Bowery Bhoys." Bradley was not cut out for farm work and ran away several times before his parents allowed him to return to the city at age sixteen. Seeking some sort of gainful employment that might teach him a useful trade, he went to work in the brush factory of Francis P. Furnald, located on Water Street. After an apprenticeship "fraught with

much hard labor and study," the bright and ambitious young man rose to the position of shop foreman at the age of twenty-one. Along the way, he left the faith into which he was baptized and became a devout Methodist.[3]

Bradley had higher ambitions than being a shop foreman. During his time at Furnald's he managed to save $200, and in 1857 he went out on his own as a brush manufacturer, supported by his wife, the former Helen M. Packard. It was a bad year to start a business. A general economic downturn that began in 1856 was followed by a series of agricultural, railroad and speculative real estate bubble bursts, which led to bank failures in 1857 and created what would today be called a "Depression," but was then styled a "Panic." In the faltering economy, over five thousand businesses failed in one year, and urban unemployment and real hunger, unmitigated by social programs or unemployment insurance, created widespread unrest. Nevertheless, Bradley and his little business muddled through. He "stemmed the tide of disaster," in his own case at least, through hard work, sympathetic creditors and probably more than a little luck. The general economy failed to recover fully, however, until the government spending spree created by the beginning of the Civil War in 1861. Demand for brushes for both military and civilian use skyrocketed, and Bradley's fortune was made.[4]

No matter his success, by 1869 James A. Bradley's health was "broken," and he was in a state of "nervous exhaustion" that could be interpreted, using modern definitions of psychological disabilities, as a siege of depression. Searching for a cure, he took the advice of David H. Brown, a fellow Methodist met by chance while walking down Broadway in May 1870. Brown, who was treasurer of the newly founded Ocean Grove Association—a "camp meeting" group in the process of establishing a religious resort on the New Jersey Shore—encouraged the brush manufacturer to buy a plot of land in the nascent community for a vacation home. Desperate for something to raise him out of his doldrums, Bradley impulsively agreed. "Put me down for two," he said to Brown.[5]

Bradley traveled south in the company of some other Methodist laymen and ministers on a visit to his sight-unseen investment several days later. The group took a boat to Port Monmouth, New Jersey, and then a train to Eatontown and rode from there to Ocean Grove in stagecoaches or carriages over "one of the worst" roads they had ever seen. On arrival, however, the jaded New Yorker found himself, he recalled years afterward, "completely taken with Ocean Grove and its surroundings." Accompanied by John Baker, his "colored man" and faithful servant, Bradley threw up a tent in what Baker thought "a wilderness," then he lay naked on the night beach as the tide roiled around him and felt renewed.[6]

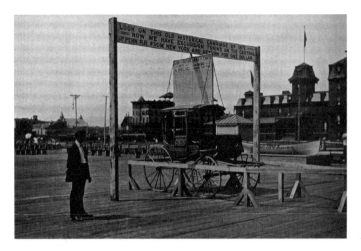

The boardwalk with one of Bradley's hand-lettered signs and exhibits—a stagecoach like the ones that used to bring tourists to the area before the railroad. *Courtesy Anne Ryan.*

For the rest of the summer, Bradley commuted back and forth between Ocean Grove and New York City on an irregular basis. The trip was eased by the extension of the railroad to Long Branch, then the vacation jewel of the North Jersey coast. Long Branch was one of the most well-known resorts in the nation, and it was certainly no Ocean Grove. A visitor to the town's many saloons could rub shoulders with robber barons, politicians, gamblers, horse racing touts, prostitutes and other "sporting" types whom the good Methodists praying in the wilderness retreat to the south found, to say the least, repulsive. Methodism, which had originated in the eighteenth century as a religion dedicated to the outcast and downtrodden, had by the mid-nineteenth century become a creed more at home with the middling classes and genteel well-to-do. Harking back to the theological purity of their roots, many Methodists came to believe that they should, for at least part of the year, set themselves apart from secular society for prayer, reflection and renewal. The best way to do this, they decided, was through a controlled re-creation of the rowdy evangelical camp meetings of the earlier part of the century. That idea, what historians have come to call the "holiness movement"—featuring fundamentalist Bible-centric religion stiffened by a sense of conservative moral rectitude—found a home in a number of places, chief among them Ocean Grove. At "the Grove," Methodists, sheltered from the Philistines by the ocean to the east, lakes to the north and south and a stout fence to the west, came together each summer in tents and cottages for large annual camp meetings. The town also hosted gatherings of Protestant reformist and social groups, including the Woman's Christian Temperance Union, the New Jersey Sabbath Union and others. Although the occasional cigar got smoked in private, the odd novel was read in secret and someone may even have

tippled a tad in his tent, life and recreation in Ocean Grove were stringently regulated, by authority and consensus, so much so that a tour guidebook author concluded that vacationers there submitted themselves to "a religious autocracy, which is severe in both its positive and negative regulations."[7]

In 1871, there was nothing between the Jersey Shore sin capital of Long Branch and the holiness haven of Ocean Grove but marshes, inlets and sand dunes held together by beach grass, scrub oaks and dwarf pine trees twisted into grotesque shapes by constant sea winds. To a modern environmentalist, this stretch of shore, judged fit for nothing useful since colonial times, would seem an ecological wonderland. To a Victorian businessman, it was wasted real estate. James Bradley, inspired and revived by the idea of Ocean Grove and taken with the Jersey Shore in general, hacked his way through the brush northward to a lake, which he later described as a "beautiful sheet of water," and concluded otherwise. To him, the wasteland provided an opportunity to create a vacation Promised Land in his own image, a resort with tamed and accessible natural wonders, which, coincidentally, served as a buffer between Long Branch and Ocean Grove. Bradley desperately wanted to buy it and, although he could interest no partners, mortgaged his business and spent $90,000 for five hundred acres directly north of the Grove.[8]

Bradley named his planned resort community Asbury Park in honor of pioneering Methodist missionary and bishop Francis Asbury, who came to America in 1771 and remained until his death in 1816. Asbury was a close associate of John Wesley, founder of Methodism, and became the leading cleric of the American branch of the church. Asbury Park would be Bradley's tribute to the father of American Methodism. His planned resort was designed to be attractive to and demonstrative of the values of middle-class white Protestant America but without the theological intensity of Ocean Grove. In his pitch to a broad swath of that population, Bradley sought a wider audience than Methodists seeking a direct summertime connection with God. Although unsurprisingly, as a devout Christian first drawn to the shore by the example of Ocean Grove, he banned the sale of alcohol within his new community's boundaries. The Founder had a somewhat progressive, if paternalistic, sense of modernity, and his plan for Asbury Park proposed an urban landscape of wide streets and large lots. In subsequent years, he established a board of health and the first sewage system on the New Jersey Shore. Primitive and narrow boardwalks were laid on the sand along the beach in 1877 and 1879 but were superseded by a more substantial "promenade boardwalk" with benches every ten feet in 1880. James A. Bradley's resort rapidly flourished, and within a few years it was attracting as many as fifty thousand summer visitors a year.[9]

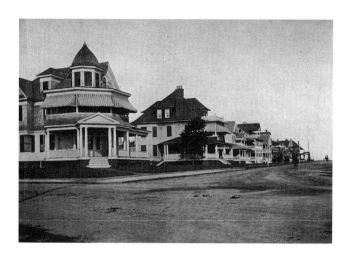

Second Avenue,
looking toward the
beach, circa 1900.
Courtesy Anne Ryan.

By 1885, when Bradley took time to reflect on his achievement, he seemed to have some second thoughts, noting that perhaps "we have built too fast and too carelessly." Although his original dream might have been modified by events, Asbury Park was, by all objective standards, thriving. The 3,000 permanent residents, hundreds of hotels and boardinghouses, seven churches, a functioning public school and a vibrant family-oriented tourist industry provided all the trappings of a very successful community. Visitors could bathe in the ocean, partake of innocent boardwalk amusements or fish in lakes off the Bradley-built pier jutting out into the ocean or on readily accessible party boats. One account claims that there were 600,000 summer visitors to Asbury Park in 1883. By the end of the decade, the city, which drew tourists from the urban and suburban centers steadily spreading outward from New York and Philadelphia, was among the top three resorts on the Jersey Shore, along with Long Branch and Atlantic City. In strong contrast to the other two towns, however, with their diverse honky-tonk character, Asbury Park bore the indelible, respectable middle-class imprint of the Founder. He was everywhere and anywhere, impulsively intervening to give guidance to visitor and resident alike whenever he thought it necessary.[10]

Second thoughts aside, by the following year Bradley supported the creation of a streetcar service in Asbury Park, spurred by the existence of a horse-drawn car service in Point Pleasant. Prodded by the Founder, the city commission, despite the opposition of stage and carriage drivers, carefully considered the subject and finally approved it in February 1887, not only as a service to citizens, but also as a potential municipal fundraiser through a tax on the service provider. The original idea of horsecars faded, however,

James A. Bradley, the Founder

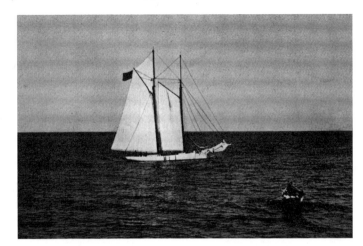

The yacht *Emma B* was an early "party" fishing boat that made daily trips from Asbury Park. The photo is circa 1900. *Courtesy Anne Ryan.*

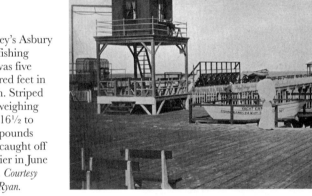

Bradley's Asbury Park fishing pier was five hundred feet in length. Striped bass weighing from 16½ to 27¼ pounds were caught off this pier in June 1900. *Courtesy Anne Ryan.*

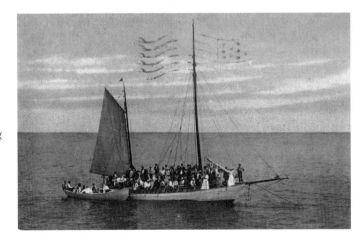

The party fishing boat *Carib*, like the *Emma B*, had its patrons rowed out from the fishing pier. *Courtesy Asbury Park Library.*

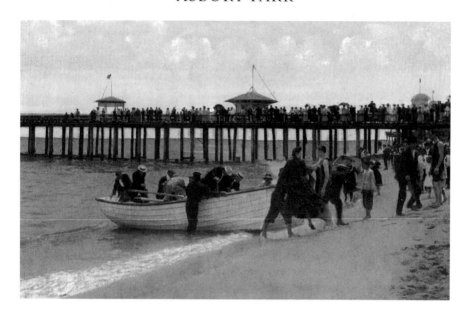

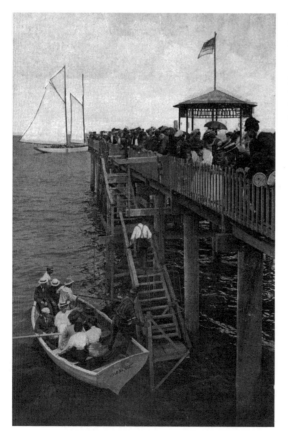

Above: Patrons coming ashore after a day of fishing on a party boat. *Courtesy Asbury Park Library.*

Left: Fishing boat patrons leaving the pier for a trip on the *Emma B* or the *Carib*. *Courtesy Asbury Park Library.*

before a proposal to build an electric system submitted by the Sea Shore Electric Railway Company, which was accepted in May. Asbury Park's first electric trolley rolled down the tracks in September 1888. Over the years, the line had its ups and downs and went through several different ownerships, with expanded then dwindling trackage, until its final day on October 22, 1931, when it gave way to a bus route.[11]

Bradley, sometimes the official mayor, always the unofficial gadfly, spent a lot of time supervising and interjecting himself into many of the day-to-day affairs of Asbury Park, including regulating the boardwalk concessions of which he retained personal ownership to make sure there was no gambling. On one occasion, he "raided a 'doll game' and with an axe smashed the appliance with which the dolls were won or lost." However, as the city developed, another oppositional strain—a commercial one—began to assert itself in a growing merchant community whose aims differed to a greater or lesser degree from that of the Founder, and an 1892 advertising brochure characterized Asbury Park as "essentially a secular community."[12]

BRADLEY ON CRUSADE

Bradley's greatest personal efforts were directed toward keeping demon rum, and beer as well, from being sold in Asbury Park. His father's death from alcohol abuse may well have reinforced the Founder's Methodist prohibitionist spirit, and the rampant alcoholism of late-nineteenth-century America certainly made it a viable public philosophy. A state charter granted to the town in 1874 specifically allowed the prohibition of liquor sales within its boundaries. Subsequent state legislation was passed forbidding the sale of liquor "within a mile of a camp meeting resort" like adjacent Ocean Grove. Bradley, whose many enthusiasms waxed and waned over the years, conducted an off-again, on-again struggle against "beer arks" and "speakeasies" catering to thirsty residents and vacationers alike in his model city by the sea. Although it was illegal to sell liquor in Asbury Park, private possession of alcohol, while frowned on, was not outlawed and even protected by state law. Beer arks, their fanciful names a play on words recalling Noah's saving the day for mankind, were actually wagons that rolled in from nearby towns to legally deliver the products of local beer bottlers to individual citizens and hotel and rooming house proprietors who had, allegedly, previously ordered their products, by the case only, at another location. It seems, however, that at least some of the arks not only delivered orders but also apparently sold their products to

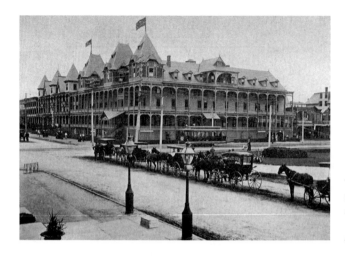

The West End Hotel, a popular hostelry in Asbury Park, circa 1900. *Courtesy Anne Ryan.*

anyone who approached them with money, in clear violation of the Asbury Park law, making the city's claim of alcohol prohibition, by one account, a "delusion and a sham." According to the *New York Times*, although thousands of vacationers were drawn to Asbury Park specifically because alcohol sales were prohibited, many others were not so motivated, and an imbiber would not "die of thirst as long as he has the price of a drink."[13]

Bradley's alcohol enforcement, like much of his other behavior, was impulsive and erratic. When he was on his game, the Founder hired special police officers to chase the arks. On other occasions, however, he concluded that the only way to control retail alcohol sales was by actually allowing them but charging high license fees to dealers, to "make them pay dearly for the privilege of selling," although he never actually adopted this practice. In the summer of 1891, the Founder decided to conduct active operations against the mobile beer dealers (who also sold rum and whiskey) in an attempt to drive them out of the city. In July, he hired a number of boys as spotters, provided them with horse-drawn sulkies and directed them to follow the arks around town, making notes of deliveries. Bradley then published purchasers' names and addresses, as well as the quantity of beverages delivered to each, in his private newspaper, the *Asbury Park Journal*, in an attempt to limit liquor consumption through public embarrassment. After tabulating his observation team's compiled figures (which he did not reveal), he pronounced himself staggered by the results and concluded that Asbury Park actually appeared to have a higher per capita alcohol consumption rate than Long Branch, where "the saloons were wide open." Drawing conclusions from his data, Bradley posited that the requirement for beer arks to sell by the case might cause a theoretical "young man" to keep drinking until he consumed the

whole case and then ordered another case, until he was "likely to fall and become a drunkard," a situation that complicated the argument for overall prohibition in Asbury Park and caused Bradley to consider the "high license" option, where his "young man" might be satisfied with two expensive glasses of barroom beer.[14]

Bradley pursued legal measures, as well as intrusive social sanctioning, in his attempt to stifle the beer trade. He filed complaints against individual ark admirals, including William R. Jernee of Spring Lake, a former state assemblyman, and William Griffin Jr. of Long Branch. All of these charges were dismissed due to lack of evidence, however. By the fall of 1891, most observers concurred with a newspaper headline declaring "Founder Apparently Worsted by Beer Men." The "beer men" were credited with having "disposed of enormous quantities of the German beverage" not only in Asbury Park but in Ocean Grove as well. On this note, Bradley gave up and took off to the White Mountains of New Hampshire for a vacation.

The aging Founder returned to the beer ark battle a final time in 1911. By that date, most of the ark drivers, once from old Monmouth County families, were Italian immigrants operating out of Neptune Township. When Bradley interfered with the trade this time, he received a letter written in Italian advising, "If you do not stop persecuting the merchants of beer, you will know quick the power of the Black Hand. But it is too late. THE BLACK HAND." Bradley responded with a counterthreat addressed to "Beer Ark Pirates" and published in both Italian and English in local papers, advising that he had turned the letter over to the police, who would punish the writer and his associates "according to law." He further stated that should he be killed, he would leave instructions in his will to hire detectives to "hunt down" the perpetrators. In the end, this tempest in the proverbial teapot appears to have had no effect one way or the other on the beer transportation trade, which continued until national prohibition drove all alcohol sales somewhat underground.[15]

There were ways to foil the Founder and sneak a drink in Asbury Park other than the relatively public one of buying from a beer ark driver, however. The "speakeasy," an institution that grew famous during the national experiment in alcohol prohibition of the 1920s, had at least some of its origins in James A. Bradley's Asbury Park. In 1895, those seeking a schooner of lager beer in a Kingsley Street establishment would order "sea foam." The code words for a stiff shot of whiskey were "cold tea." You could also buy a drink somewhat openly, albeit illegally, in a number of hotels, restaurants and billiard parlors. In the summer of 1905, local police charged nine hotel proprietors, along with a beer ark driver, with illegal liquor sales.[16]

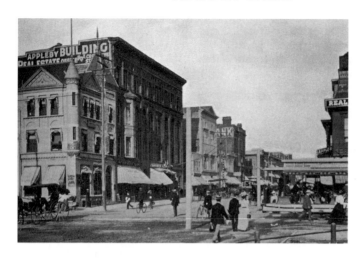

Looking down
Mattison Avenue
from the train
depot, 1900.
Courtesy Anne Ryan.

In a pinch, if you knew Joe Patterson, you could also get a drink at the New York and Long Branch Railroad freight depot in town. Patterson, the depot manager and son of former New Jersey assemblyman George W. Patterson of Wall Township, appears to have acquired his job through his father's political influence with New York and Long Branch president and U.S. senator Rufus Blodgett. Once installed as manager, Patterson converted the depot office into a "beer guzzling" station for himself and his friends. Detective David H. Burd of Bradley's "Law and Order League" subsequently preferred charges against Patterson, who accosted the detective and "a friend," perhaps Bradley himself, on Lake Avenue in July 1888. Bradley's newspaper reported the encounter, accusing the "vulgar and abusive" Patterson of using "language… of the vilest kind and such as an ordinary tramp would be ashamed of" and of threatening to throw Burd "under the wheels" of a passing train should he ever come near the freight depot again. Patterson subsequently sued Bradley for criminal libel and had him arrested. During the subsequent court case, the elder Patterson, who had served as an officer in the Fourteenth New Jersey Infantry in the Civil War and was a pretty tough customer, made a scene in court "in a frenzy of excitement and passion" and had to be restrained from going after Bradley himself when the Founder characterized his son as leader of a group of rowdy characters who merited "constant police surveillance" on the beach and elsewhere. This and other lawsuits, all of them revolving around liquor and most ending inconclusively, provided a constant source of stories and amusement to local journalists until Bradley began to slow down his prohibition efforts in the mid-1890s.[17]

One of those amused was Stephen Crane, who trod the Asbury Park boardwalk before gaining fame as a novelist. Crane, whose mother had

moved to Asbury Park on the death of his father, lived in the city off and on and worked as a stringer for the *New York Tribune*. He was by turns outraged and bemused by Bradley's eccentricities and in 1896 accurately pegged the Founder as a complex character, who lectured and hectored the citizenry and enacted "ingeniously silly" regulations yet was capable of "deep and fine" acts of philanthropy. Crane's Asbury sojourn ended when his often-sarcastic reporting led to Bradley's *Journal* attacking his stories as slanderous, which in turn led to the *Tribune* severing his services. The last straw for his employer was a barrage of complaints regarding Crane's coverage of an Asbury Park parade of the Junior Order United American Mechanics (JOUAM) and his characterization of them as "stolid" working folk, which offended their sense of class. In reality Crane had erred, since the JOUAM was not merely some aggregation of artisans but actually a political organization dedicated to promoting anti-Catholic and anti-immigrant government policies.[18]

Many JOUAM members may have been prohibitionists as well, but lax members could wet their whistles in Asbury Park in even more creative ways than previously described. In addition to beer arks and "speakeasy" semisecret saloons, a drinker could buy "medicinal" alcohol for home consumption from several pharmacies in town with a real or forged doctor's prescription. Druggist William R. Ham was included on the list of those charged in 1905, and drugstores may well have been among the earliest sources of illegal liquor in Asbury Park. One such establishment was owned by pharmacist Daniel Heustis and his physician brother Dr. H.F. Heustis. In the early 1880s, the Heustis brothers were dispensing liquor to customers who presented prescriptions allegedly written by Dr. Eugene Laird, a prominent Long Branch physician, calling for a pint of whiskey "to be taken as directed." When Bradley caught on to the pharmacy scam, he sought and received a Monmouth County Grand Jury indictment of both brothers. Dr. Heustis responded by claiming that he had relinquished his interest in the business. The pharmacy immediately closed, and the charges against the owners were subsequently dropped. Shortly afterward, however, Daniel reopened the pharmacy, was quickly charged by Bradley with an undisclosed "serious crime" and fled the state to Brewsters, a village in Putnam County, New York, where he was subsequently charged with attempting to burn the town down and incarcerated. Locals among whom Heustis settled in New York considered him a "lunatic" and "a drunk." The Heustis pharmacy may well have been one of those drugstores where, according to James A. Bradley, "young girls were taken, drugged and ruined."[19]

The surges of young love were almost as much a threat to civil society as beer arks, thought the Founder, who posted signs around town "warning

parents to properly instruct and safeguard their children against evil forces." Preventing adolescent male-female "summer time propinquity" was as much a crusade theme to Bradley as chasing liquor dealers. In 1891, he erected a sign reading, "No persons will be allowed to pass this point after dark for reasons known to the police" at a popular meeting place for "love struck maidens and youths" at the end of the boardwalk near Deal Lake. Similarly, after some people apparently ignored his sign "warning parents of girls to avoid night boating on Deal Lake," he had city police patrol the lakeshore, flashing lights on trysting couples in rental canoes. Bradley was a great fan of Anthony Comstock, who had graduated from delivering annoying lectures to his fellow Civil War soldiers on their use of profanity to a career as a self-appointed custodian of public morals, crusading against the mailing of what he considered lewd and lascivious material, including birth control information, the plays of George Bernard Shaw and literature promoting the ideas of prominent suffragist and free love advocate Victoria Woodhull.[20]

RACISM IN THE PROMISED LAND

Resort towns certainly attract young lovers, as well as the probably-more-than-occasional lunatic drunk like Heustis, but they cannot make it function. Asbury Park needed people to cook, clean, make beds and generally maintain its hotels and rooming houses, as well as keep the beach and boardwalk tidy and in good repair. Addressing the desires of prosperous year-round residents in an age of household drudgery when "hired help" spelled leisure to middle- and upper-class white women also created a need for personal servants. The workforce that fulfilled those needs in Asbury Park was largely black, resulting in a considerable African American presence, estimated at some two thousand people by the 1880s. While a veneer of integration was provided by "live-in" maids, nannies, cooks and carriage drivers in the homes of the city's well-to-do residents, most African Americans resided in what writer Daniel Wolff has characterized as the "second city" of "West Park," an adjacent unincorporated section of Neptune Township quite literally on "the other side of the tracks" from Asbury Park proper. Although the northern section of West Park became a desirable residential address, the southern section, based on a property development by Morristown attorney Frederick G. Burnham, gave birth to a freewheeling community centered on Springwood Avenue, an extension of Bradley's Lake Avenue beyond the railroad tracks to the west. The Springwood neighborhood was initially largely black but also became, as the years went by, home to Jewish

merchants and an increasing number of Italian immigrants who came to town to work on trolley line construction and decided to stay. The West Park community was beyond Bradley's censoring grasp, and as early as 1885 there were newspaper complaints of "stage loads" of New Jersey National Guard soldiers returning "crazy drunk and singing and yelling at the full strength of their lungs" from "some of the low saloons and disorderly houses in "the suburbs of Asbury Park" to their camp at Sea Girt.[21]

In addition to workers from West Park, who visited the beaches after their workdays were done, Asbury Park began to attract black tourists "day tripping," along with white vacationers, by train from Northern New Jersey and New York. The presence of so many black faces around town made it seem to some that Bradley's white middle-class nirvana was threatened. The Founder's personal newspaper, the *Asbury Park Journal*, editorialized that there were "Too Many Colored People" in town. Most offensive to the writer was that the "colored people," workers and tourists, were using the beach and boardwalk just like white folks; he requested that the Founder do something about it. Since Bradley wrote much of the paper himself and approved the rest, the request was somewhat disingenuous.[22]

White visitors who did not like to converse or rub shoulders with black people wanted "impudent" African American maids, waiters and vacationing

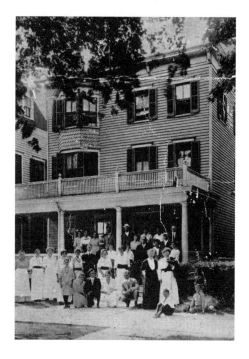

The owners and staff of the Melrose Hotel in the early twentieth century. This is one of the rare images of Asbury Park in that era that shows the African American workers in the hotel industry, standing on the porch in the back row. *Courtesy Asbury Park Library.*

picnickers either banned from the beach and boardwalk or segregated to a portion of it. A definition of exactly what that "impudent" behavior was went undiscussed. Reaction from the African American community was rapid. Reverend A.J. Chambers of West Park's Bethel African Methodist Church quickly retorted that there was no substance to any of the allegations made by the *Journal* and that his parishioners had attended services in Ocean Grove without any sort of complaints about "impudence." Ironically, the black Methodist church was born when Bishop Asbury segregated a congregation during the American Revolution, but James Bradley's brand of Methodism had pre–Civil War abolitionist affiliations. Still, as one New York newspaper noted, the majority of white people visiting Bradley's town "prefer not to come in contact with black people on anything like terms of social equality." That undeniable fact evoked gleeful criticism from a Texas newspaper, which characterized it as hypocrisy in the light of Northern criticism of Southern segregation. As the controversy continued, Bradley, who had made no attributable public comment on it, took off on a summer vacation to Europe.[23]

Bradley revisited the racial issue annually throughout the 1880s, sometimes by long-distance correspondence from a vacation lair in Wiesbaden, Germany. His arguments in favor of segregation of some kind and even the exclusion of African Americans from the beach and boardwalk altogether ranged from an admonition that the white Asbury Park paying visitor should be made a "welcome guest" by the city's "colored servants," who should cater to tourists' prejudices by making themselves scarce, to the position that the boardwalk and beach were his private property, and if an African American presence there resulted in his losing money, a secular mortal sin in the Gilded Age, he was legally entitled to end it. Equal rights, according to Bradley, touting a thinly veiled Social Darwinist ideology, were "an impossibility," so the "colored servants" might just as well get used to life as it was and always would be.[24]

Asbury's African Americans responded once more, this time in the person of James Francis Robinson of the Methodist Episcopal Zion Church, a dynamic minister with considerable verve. At an "indignation meeting" held before a cheering mixed-race audience on June 17, 1887, Robinson dismissed suggested talking point guidelines sent to him by the Founder as patronizing and insulting "rubbish." He proceeded to deliver a fiery sermon in which he cited the significant contributions of black Americans to the city of Asbury Park, which could not function without them, and the country as a whole, in the past and present. "We helped save the Union," exclaimed Robinson, alluding to the enlistment of over 180,000 black soldiers, some

3,000 of them Jerseymen who had served in the Union army two decades earlier. In his military allusion, the minister may well have been making an ironic comment on Bradley himself who, thirty-one years old at the outbreak of the war, not only failed to serve but also made a fortune selling brushes to the military. "We are a free people," said Robinson, "and we have the same rights by law as our fellow-citizens whose skins are white." In a subsequent speech in New York, he ventured the opinion that reading the *Asbury Park Journal* made a reader think "it was edited in Georgia."[25]

Bradley, who no doubt became aware that he was not dealing with patsies, backed off his patronizing racial rhetoric and then offered the absurd argument that his segregation theories had nothing to do with race, but class. He maintained that he held all "respectable people" in esteem and would react with as much disfavor toward any ethnic group that offended his tourists and threatened the business community. The weakness of this argument is exposed in the Founder's treatment of Joe Patterson, however. Although Patterson and his friends were considered troublemaking drunks and lowlifes, they merely merited police surveillance on the beach, whereas black people were, by the very nature of their race, considered "impudent" and totally unwelcome for merely showing up. In the end, Bradley compromised by establishing bathing hours during which black people would be allowed access to the beaches—a solution that, although it would not have satisfied Reverend Robinson, was accepted by enough people in the black community to quiet the controversy for a while. In ensuing years, however, the Founder continued his efforts to present as much of a "white beachfront" to his presumed racially intolerant tourist base as possible. In one example, he specifically disallowed, by city code, visibly "ethnic"

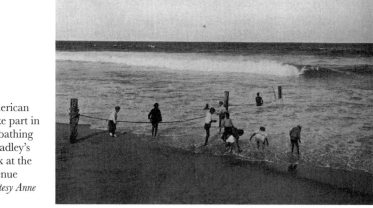

African American children take part in segregated bathing in James Bradley's Asbury Park at the Second Avenue beach. *Courtesy Anne Ryan.*

musicians from playing in boardwalk band concerts. When Mayor Frank L. Ten Broeck tried to repeal this measure in 1888, he was overruled by Bradley loyalists on the city council. Asbury Park's segregation would last startlingly long into the twentieth century, with results that would eventually almost destroy the city.[26]

Atlantic City, another New Jersey resort dependent on black labor for its existence, was jealous of Bradley's segregation success. An 1893 editorial in that town whined, "What are we going to do with our colored people?" The writer went on to complain, similarly to the *Journal* editorialist, that "both the boardwalk and Atlantic avenue fairly swarm with them," and that their presence "is offending the sensitive feelings of many visitors, especially those from the South." He bemoaned the fact that when one considered the "thousands of waiters and cooks and porters [and] are added the nurse girls, the chambermaids, the barbers and bootblacks and hack drivers and other colored gentry in every walk and occupation of life, it will easily be realized what an evil it is that hangs over Atlantic City." Despite this, however, historian Charles Funnell points out that Atlantic City was never able to establish a truly segregated beachfront. Funnell attributes the contrast to the fact that Bradley held tight control over the boardwalk and beach, whereas its rowdier rival down the coast had so many property owners along the oceanfront that such a unified policy was impossible. While unofficial segregation persisted in Atlantic City into the modern era, with a "black beach" known until recent times as "Chicken Bone Beach," it was incomplete and inconsistent, particularly in the case of the boardwalk, in comparison with Asbury Park.[27]

Perhaps ironically—considering the controversy and Reverend Robinson's pointed reference to the Civil War, and although there was no Asbury Park before, during or in the immediate aftermath of the conflict—the town ended up with a Civil War monument. The standard story surrounding the statue is that Bradley purchased it and installed it on the boardwalk, probably as one of his whims to present "interesting artifacts" on the boardwalk and beach to educate, entertain and enlighten children and the general public and at the same time make visiting veterans (a lucrative late-nineteenth-century tourist and convention marketing target) feel welcome. Dates of the purchase vary, and one account places it in the 1870s, which seems very unlikely. After viewing photographs of the statue, nineteenth-century statuary expert Carol Grissom of the Smithsonian Institution concluded that it is made of sheet copper and is almost identical to a generic statue listed in the 1891 catalog of the W.H. Mullins company of Salem, Ohio, priced at $300 for a six-foot-high version and $450 for one nine feet tall.[28]

James A. Bradley, the Founder

The Civil War monument shortly after its 1893 installation. *Courtesy Asbury Park Library.*

An 1889 tour guide mentions the statue as located "at the bathing pavilion on the southern limit of Asbury Park." The statue was subsequently moved from that site and permanently installed in its current location, a few blocks from the ocean in a small triangle park at the intersection of Cookman and Grand Avenues, flanked by two small boat howitzers. It was dedicated with much hoopla by the Caldwell K. Hall Grand Army of the Republic post and other fraternal organizations on Memorial Day 1893. Although a close examination reveals that the statue is literally coming apart a bit at the seams, Ms. Grissom opined that it actually "looks pretty good" in photographs, especially considering its age and environment.[29]

Asbury Park residents would soon begin over a century of going off to other wars. The city's National Guard unit, Company A of the Third New Jersey Infantry Regiment, was called to active service for the Spanish-American War on May 2, 1898, with a first stop at the National Guard camp at Sea Girt. Although prepared to go overseas, the company was assigned to guard duty protecting a gunpowder plant at Pompton Lakes, New Jersey, and then moved on to Athens, Georgia, in November. The Third Regiment was discharged on February 11, 1899, and Company A returned to Asbury Park on February 15. A half century later, the unit's surviving veterans recalled that the worst part about their service was terrible army food. Future Asbury Park soldiers would not be so fortunate.[30]

The same year the Civil War monument was dedicated, James A. Bradley tested the political waters. A candidate for New Jersey State Senate on the Republican and Prohibition tickets, he ran a campaign that a commentator

The Asbury Park Civil War monument in 2008. *Courtesy Joseph Bilby.*

characterized as "picturesque." The Founder handed out "scrubbing-brushes with campaign legends of one kind or another upon them, among the housewives of the county, and shining silver dimes among the younger fry as a temptation to commit his campaign songs to memory." He was victorious, largely due to a "throw the bums out" feeling on the part of the general public, fed up with corruption highlighted by legislators deeply involved with horse racing and seen to be doing the bidding of gamblers for financial favor. Bradley's legislative career was brief, but he did cast the deciding vote ending horse racing in New Jersey, a ban that stood for generations. The residents of Long Branch, a racetrack town and competitor for resort tourism, viewed his vote, which followed on the heels of a petition he circulated against racing several years earlier, as less than idealistic.[31]

Despite his restrictions on certain forms of entertainment and his bumbling lack of progressivism and tolerance on racial matters, James A. Bradley did follow through on his initial vision of Asbury Park as a more entertainment-friendly version of Ocean Grove, approving an effort of enthusiasts and merchants who made the city, for a short time, an athletic mecca and then came up with a gimmick contest that made Asbury Park famous nationwide.

James A. Bradley, the Founder

RISE OF THE WHEELMEN

"Asbury Park is still alive; we want the meet for '95!" was the chant of a group of ambitious Asbury Parkers who were determined to bring the annual meet of the League of American Wheelmen to their city in 1895. The league, a national group of bicycling enthusiasts with clubs throughout the country, including one in Asbury Park, represented big money for whatever town could secure its business. The national meet, first held in Newport, Rhode Island, in 1880, was a prestigious event that subsequently took place in important urban centers such as Denver, Chicago, Detroit and Washington. Although the comparatively tiny resort of Asbury Park was inconsequential next to these metropolitan hubs, city promoters were confident that they could secure the bicycling competition and the massive amount of tourism dollars that would follow. And so, at a spirited meeting of Asbury's League of American Wheelmen chapter on an otherwise quiet December night in 1894, the group vowed to aggressively pursue the chance to host the event. Ex–state consul William H. Stauffer told his fellow league members that the chances of securing the "coveted meet" were "very bright, provided the Jersey wheelmen would use their influence to further the scheme." Encouraged by Stauffer's enthusiasm, the league appointed a committee of influential members—John D. Beegle, Joseph L. Cliver, Dr. Asher S. Burton and Mayor Frank L. Ten Broeck—to secure the prize.[32]

Yet underneath the self-confident "hurrahs" that night there must have lurked some doubts and insecurities, for Asbury Park had been embarrassingly defeated the year before in its attempt to host the meet. In 1893, the chapter had sent a committee to Louisville, home of the group's National Assembly, armed with a guaranteed entertainment fund of $10,000 that demonstrated an ability to provide a lavish backdrop for the bicyclists. The members of Asbury's delegation felt that they were on the verge of success, but a behind-the-scenes maneuver by representatives from Massachusetts swayed assembly members, ending in an unexpected coup for Denver.[33]

For the ambitious merchants of Asbury Park, securing the competition would be an undeniable public relations achievement, since it was a media magnet event that reflected the nation's obsession with the sport. By the 1890s, cycling had become young Americans' favorite pastime for exercise and enjoyment, and owning one's own set of "wheels" represented freedom and excitement. The sport gained popularity when the old "high wheeler" bike was replaced by a rubber-tired, low-slung "safety" bicycle with equal-sized wheels. The comparative ease of learning to ride the new model, as opposed to the risky balancing act involved with mastering the old high

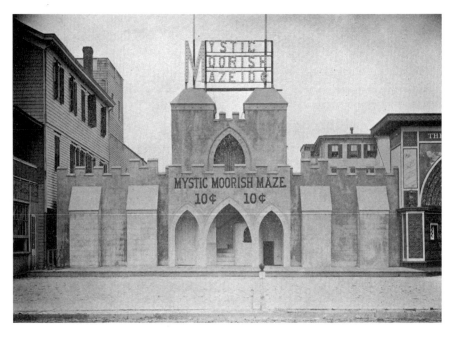

A popular Asbury Park amusement, circa 1900. *Courtesy Anne Ryan.*

Amusements along Ocean Avenue, circa 1900. *Courtesy Anne Ryan.*

wheeler, even opened the sport to women, who were tentatively exploring more avenues toward independence.[34]

At the forefront of this national obsession was the League of American Wheelmen, a group started by a small number of enthusiasts in 1880 that, less than twenty years later, boasted a membership of an estimated 100,000 cyclists throughout the United States. The league was known for its century runs, one-hundred-mile trips that had "become so common that almost every club indulges in several during the season," according to a newspaper account. A.O. McGarrett, chief centurion of the Massachusetts Division of the Century Road Club, advised novice riders to attempt no more than twelve miles per hour. "Many begin at too fast a pace," he warned. "Twelve miles an hour is fast enough to average on a century, and when this rate of speed is followed the rider will invariably finish fresh." McGarrett also suggested that participants wear minimal clothing, avoid stimulants and attach cyclometers on their wheels, since these were "valuable in designating the distance covered."[35]

Of course, the trendsetting crowd in Asbury Park was quick to join the cycling craze, and by 1890 the city's League of American Wheelmen chapter was meeting in its own clubhouse at Grand and Sewall Avenues. The group sponsored many local events, including a century run in October 1894 from Asbury Park on a circuitous route to Newark. More than one hundred athletes signed up for the journey, which began at 5:00 a.m. on October 18 at Railroad Square. After arriving in Newark about 6:40 p.m., the competitors were treated to a dinner and silver souvenirs to celebrate their accomplishments.[36]

The city had its own unique claim to cycling fame, thanks to the exploits of Arthur Augustus Zimmerman, a Jersey Shore pedaling phenomenon of international stature who often competed in Asbury events. The lean, five-foot-eleven Zimmerman, who was born in Camden and moved to Manasquan as a child, was a natural athlete whose speed and style moved him to the front ranks of bicycle track racing. He won 1,400 races between 1887 and 1903, racing in America, Great Britain, Europe and Australia.[37]

"Zimney" was a popular hero with the Asbury Park crowd and was often greeted with ovations whenever he appeared at a meet. In 1893, for example, he impressed some two thousand spectators at the annual bicycle competition along Deal Lake by capturing much of the $1,000 in various event prizes, winning the one-mile and five-mile opens with ease. In the latter race, he not only won first prize, a diamond ring, but also secured the second prize of a diamond collar button for leading in the greatest number of laps.[38]

Given Asbury Park's strong local connection and the intense public enthusiasm for the sport, city entrepreneurs realized how imperative it was

Main Street
in the 1890s.
*Courtesy Asbury
Park Library.*

to secure the national Wheelmen meet for the summer of 1895. Asbury's indomitable promoters pressed on, and their tenacity was rewarded; the league designated Asbury Park as the site of its weeklong competition. During the sultry days of July 1895, the "invasion" of cyclists, as one newspaper reporter described it, began several days before the event, with every train that chugged into Railroad Square depositing "wheels and wheelmen by the scores and hundreds...Everybody here seems to be a cyclist, and every man and woman has his and her pet wheel oiled and burnished for this great and important occasion," the writer added. The riders hailed from around the country, as far away as Denver.[39]

Once checked in at their hotels, many visitors chose to relax by strolling through the bustling downtown, perhaps stopping at the *New York Times* tent on Cookman Avenue to hear a rousing sampling of popular music provided by the New York Concert Band. Those dropping by included a number of female bicyclists, who were attracting a great deal of public attention by showing that the "fairer sex" could hold its own in matters of athletic ability. These young competitors were as enthusiastic about the sport as their male counterparts: "They ride with tireless vigor all day, [and] talk bicycles and bicycle appointments at meal time," a newspaper correspondent observed.[40]

Yet as nightfall overtook the overcrowded city, the tireless young men and women were quick to exchange their sporting wear for the formal attire necessary for an elegant evening out. Rugged male bicyclists doffed their knickerbockers and outing shirts for regulation evening dress. The ladies donned their finest silks, satins, laces and jewels, becoming once more the

James A. Bradley, the Founder

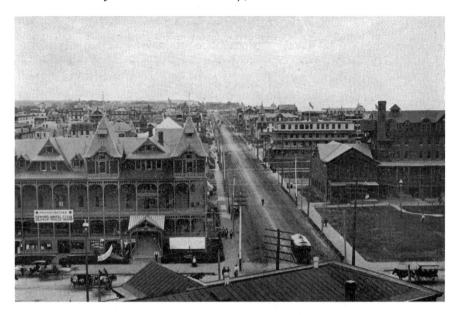

Kingsley Street looking north from Asbury Avenue. This photo appears to have been taken during the 1895 Wheelmen Convention in the city, as evidenced by the sign hanging on the hotel to the left. *Courtesy Anne Ryan.*

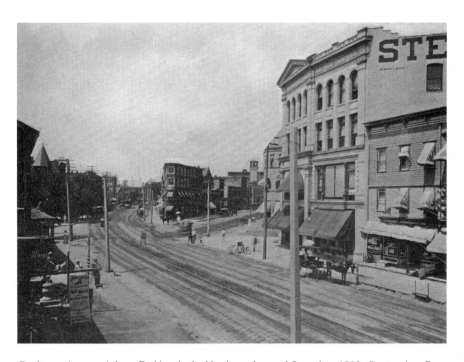

Cookman Avenue, Asbury Park's principal business thoroughfare, circa 1900. *Courtesy Anne Ryan.*

"sweet, bewitching and fascinating creatures" they were before "the bicycling craze set the fair ones to scouring the country on the 'bikes.'" The finest hotels in Asbury—the Coleman, the Plaza and the Ocean House, among others—were filled with young people who glided across waxen ballrooms to the strains of the latest waltz or polka.[41]

Undoubtedly, the days and nights of high-spirited good times—and profits—that followed during the Wheelmen's stay provided a brisk tonic for Asbury's businessmen, more bracing than the resort's invigorating sea air. It was perhaps the pinnacle of the Jersey Shore's love affair with cycling, and inevitably, as the nineteenth century gave way to the even more frenetic twentieth, the passion began to flag. The popularity of a new set of wheels—the automobile—made the bicycle seem somewhat tame and old-fashioned for a new generation of daring young people. Asbury's Wheelmen's Club, a vigorous organization of some six hundred members in its heyday, sank into a gradual decline. By the mid-1940s, its clubhouse had become the USO Club for area servicemen and was eventually razed and replaced by the St. George Orthodox Church.[42]

BABIES ON PARADE

Yet as for every fad that lost its luster, Asbury's merchants, with the blessing of the Founder (as long as it didn't involve the sale of alcohol, occasion sexual propinquity or draw too many black people to the boardwalk), were determined to supplement and then replace the bicycle craze with another that would lure even more people and profits—and on a more regular basis. Thus, in July 1890, the city initiated an annual event that would become one of its biggest, most legendary and enduring tourist attractions—the baby parade. The "unique parade," as one news reporter described it, was Bradley's personal brainchild, first held on a busy summer afternoon in 1890 at the height of the vacation season. About two hundred mothers and nurses wheeled babies in their little carriages in single file from the foot of Wesley Lake to the pavilion at Fifth Avenue and back. The popular band from the steamship *Trenton* led the procession, which was under the general direction of Bradley, who "acted as godfather of all the youngsters," according to the reporter at the scene; the writer also observed that there were "all kinds of babies." The tots were pulled in wagons decked with silks, satins, flags, streamers and Japanese lanterns. There were even several carriages carrying twins. An estimated fifteen thousand people witnessed the spectacle, and in the following days, Asbury's promoters were already describing it as a strong

James A. Bradley, the Founder

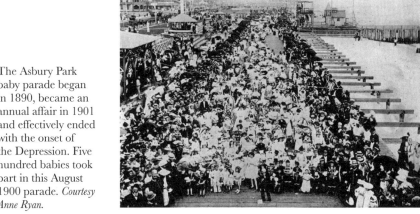

The Asbury Park baby parade began in 1890, became an annual affair in 1901 and effectively ended with the onset of the Depression. Five hundred babies took part in this August 1900 parade. *Courtesy Anne Ryan.*

addition to the annual lineup of summer events. The parade was an ideal promotional tool because it strengthened the city's reputation as a family resort filled with wholesome amusements suitable for a respectable middle-class clientele. After all, what was more innocently appealing than a parade of adoring mothers and their adorable offspring?[43]

Within seven years, the parade had become an event of epic proportions, with some fifty thousand people watching. While the march had warranted a brief three-paragraph write-up in the *New York Times* in 1890, the festivities were now covered in elaborate detail, with a complete listing of judges and award winners included. Mothers and nurses were busy in the hours before the 4:00 p.m. march, as they began dressing their babies and decorating the wagons and carriages. Curious onlookers began to gather on the boardwalk several hours before the kickoff, and flags and bunting waved gaily from hotels along the parade route. As fifty security guards kept the route clear of meandering pedestrians, the parade began its route at the auditorium and then proceeded down the brick bicycle walk to Second Avenue and back. Photographers snapped photos from elevated stands provided for their convenience, while the panel of judges eyed the contestants carefully from a reviewing stand on Fifth Avenue.

The categories for prizes reflected the variety of costumes and decorated carriages, ranging from the "Best Decorated Baby Carriage in Cultivated Flowers" to the "Best Decorated Girl's Tricycle." In a category reflecting the belief of the era that obesity equaled health, little William Carpenter won the today-dubious distinction of "Heaviest Boy Under One Year of Age" and received a one-year subscription to Bradley's *Asbury Park Journal* for his weight. To ensure that all participants went home happy, every child was

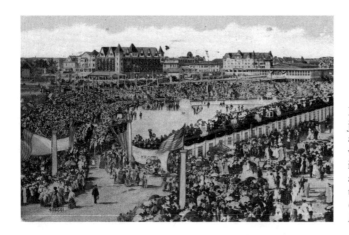

Baby parade judging and award ceremonies were conducted in a temporary amphitheatre near the boardwalk. *Courtesy Asbury Park Library.*

given a box of candy, a bottle of manufactured baby food, a blank form for recording age and achievements and a cake of toilet soap.[44]

With each passing year, the parade increased in size and spectacle. In 1901, Ocean Avenue was covered in matting to accommodate the marchers, and even the judges had acquired a more regal air. Miss Grace Crawford, gowned in a Grecian robe of "spotless white," was queen of the reviewers and rode to the judging stand in an open carriage accompanied by her maids of honor. Little Eilen Passedoit traveled all the way from Paris, France, to participate in the parade and rode in a coach trimmed in Old Glory and the tricolor of her native land. The displays were even more elaborate and included children riding on diminutive ponies, little girls pushing doll coaches containing make-believe babies and displays depicting everything from the Old Woman Who Lived in a Shoe to the Discovery of America. One reviewer gushed, "The weather was perfect, the babies were in fine fettle, and the spectators in good humor."[45]

It seemed as if nothing could halt the public's fascination with and affection for the baby parade. By 1912, it featured 700 participants and drew more than 150,000 spectators. By that time, the parade had been incorporated into a weeklong schedule of events that included a "Children's Carnival" and the coronation of Titania, Queen of the Fairies. Even through a World War and the cynical, sophisticated '20s, the event, which in a more urbane era might well be deemed a cornball display, remained a top draw. The baby parade survived well into the twentieth century; in the end, the only phenomenon that could stop it was financial disaster—the Great Depression. The last true parade was held in 1931, perhaps at least partly because cash-strapped parents had little money to indulge in such frivolities, and tourists—the ones who could afford the luxury of a holiday—were preoccupied with more pressing matters.

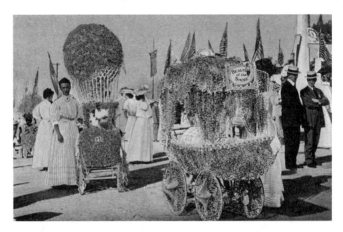

Baby parade winners. *Courtesy Asbury Park Library.*

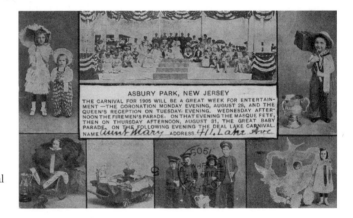

Baby parade and Masque promotional literature. *Courtesy Asbury Park Library.*

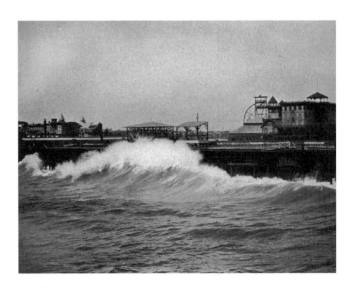

High tide at the south end of the boardwalk in 1900. Ocean Grove can be seen at the left of the picture. Also in the picture is the Plaza Hotel and Ernest Schnitzler's Ferris wheel, which was "the most popular amusement of the resort" in 1900. *Courtesy Anne Ryan.*

City publicist George Zuckerman attempted to revive the event after World War II, but his efforts were ultimately unsuccessful. Not counting a one-shot revival in the 1970s, the last parade took place in 1949.[46]

During the early years of the Gay Nineties, however, such dire circumstances were unthinkable to the successful promoters of Asbury, even though American economic history provided plenty of precedent for fiscal disaster. There was one issue that did weigh heavy on their minds, however, as the twentieth century edged closer. Publicity coups like the Wheelmen Convention and baby parade were winners for sure, and Ernest Schnitzler's 1893 Ferris wheel and carousel amusement complex on Lake Avenue by Wesley Lake attracted solid middle-class tourists. What good, though, thought the merchants, was Schnitzler's attraction or the most fantastic event when the city's prime asset—its beachfront—was becoming a rather pathetic relic of the "good old days"?[47]

END OF AN ERA

Still under the control of Founder Bradley, the boardwalk had become rather dingy and neglected at a time when pleasure seekers demanded increasingly novel diversions. While Bradley clung to the concept of Asbury as a staid bastion of Christian values, a group of more worldly Asbury Park businessmen were determined to modernize the resort and keep it in sync with changing times. Their goal was to target the evolving middle-class audience who now craved a variety of "respectable" entertainment, from "high class" vaudeville to innocent boardwalk amusements. The growing tensions between these ambitious businessmen and Bradley resulted in a showdown in 1903, when, after years of battling the tenacious merchants and promoters, the aging Founder finally relinquished ownership of the beachfront to the city for $100,000 and threw in his sewer system for $50,000 more.[48]

The move was the beginning of a key chapter in the city's history, for it marked the beachfront's transition into the twentieth century. Within a year, the boardwalk was transformed from a dilapidated relic of the '80s and '90s to a dazzling, modern amusement center. Bradley's rusting "curiosities," including old boats, animal cages and other debris, were cleared off the beach. In another modernization move, the city government sued to have trains stop at Asbury Park on Sunday. The city lavished $300,000 in borrowed money on the beachfront, and a stroll along the renovated property on a sunny day in June 1904 revealed the massive changes. At the foot of Asbury Avenue, adjoining Wesley Lake, a beautiful $50,000 casino replaced the "stuffy old pavilion" of former years. The new building, topped by four imposing

Ocean Avenue with Bradley's Pavilion on Fifth Avenue in the background, 1900. *Courtesy Anne Ryan.*

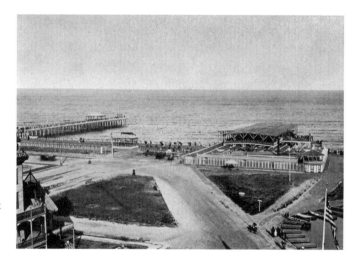

The fishing pier and Bradley's Pavilion at the foot of Wesley Lake in 1900. *Courtesy Anne Ryan.*

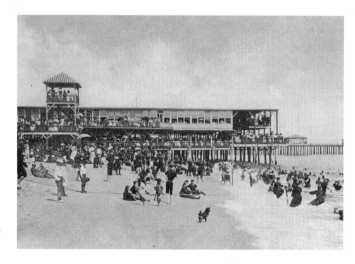

Looking north from Bradley's Pavilion, circa 1900. *Courtesy Anne Ryan.*

domes, seated six thousand people. More than three thousand incandescent lamps were used at night for lighting, and visitors enjoyed a dozen booths that sold temperance drinks, cigars and novelties.[49]

Another pavilion—known as the Arcade—was built over the boardwalk and beach at Fifth Avenue, replacing a somewhat ramshackle Bradley building. Of Moorish design, the Arcade seated close to four thousand people. At night, the imposing structure was a "blaze of light," thanks to its 3,500 electric lamps. Both the Casino and Arcade were glass-enclosed and provided with steam heat so that they could be used year-round. Just west of the Casino were a modern bathing establishment and a lighting and heating plant that provided power for the thousands of beachfront lights. The bathing enterprise contained nearly eight hundred bathhouses, as well as modern machinery for washing and drying rented bathing suits. All of these new structures were complemented by the finest landscaping available. A professional gardener worked for months converting sandy barren areas into "velvety grass plots and beautiful flower gardens." Between every avenue, miniature parks were built and filled with flower beds, shrubbery and rare plants and trees. In addition, the city bought and set out three hundred shade trees throughout the city.[50]

City promoters, anxious to capitalize on these new improvements, incorporated a variety of events into the summer lineup, including free concerts daily in the Asbury Avenue Casino from May until October. Perhaps the highlight of the social season was carnival week, a summer extravaganza held in August revolving around the baby parade that included masked balls at all the leading hotels, a firemen's parade and canoe races. Several noted "Mummer" marching band clubs from New York and Philadelphia were invited to participate in the events, and for the first time, a New York girl—as opposed to an Asbury Park maiden—was chosen to impersonate Titania, Queen of the Fairies, at the weeklong gala. John Philip Sousa protégé Arthur Pryor, a prodigy on the valve trombone and composer of the march "On Jersey Shore," became Asbury's official summer boardwalk bandmaster, and eventually a full-time city resident. In 1908, his band played an original composition, "Peek-a-Boo," to serenade the baby paraders.[51]

All in all, the first season of city beach ownership looked very promising. The season had started early—Easter Sunday—when several hotels began booking guests. Other hotels opened for business on Memorial Day weekend, when a record-breaking crowd flocked to the city. Despite the competition of the St. Louis Exposition, merchants reported that their advance bookings indicated a profitable season. Certainly, the beachfront improvements of 1904 were a success with the middle-class clientele that the

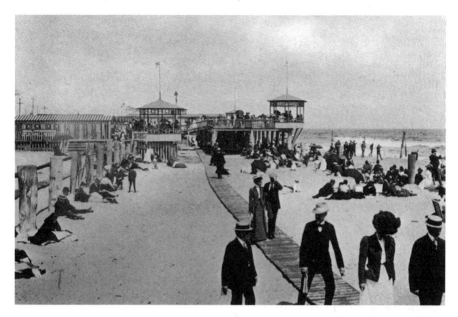

Tourists reading the morning papers on the sand near Bradley's old Fifth Avenue Pavilion, circa 1900. The city government replaced the pavilion with an arcade of Moorish design in 1904. *Courtesy Anne Ryan.*

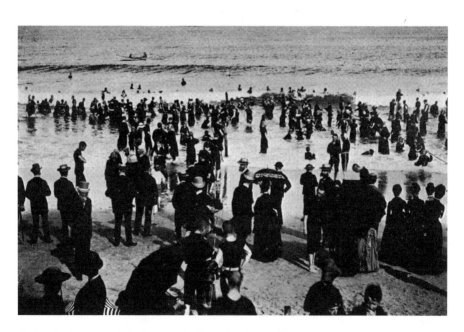

Bathers by Bradley's Fifth Avenue Pavilion, circa 1900. *Courtesy Anne Ryan.*

Left: Arthur Pryor, Asbury Park's official bandmaster. *Courtesy Asbury Park Library.*

Below: Arthur Pryor's band, entertaining visitors in the early twentieth century. *Courtesy Asbury Park Library.*

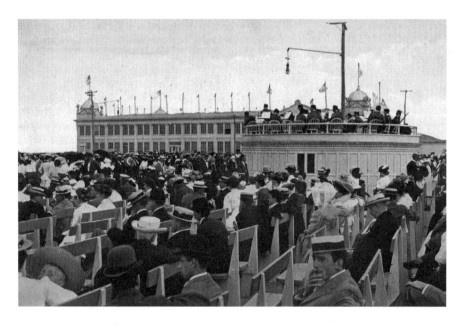

city wanted to attract. In fact, Asbury's status as a resort "where thousands find relaxation and delight" warranted a lavish full-page layout in a July edition of the *New York Times*, complete with illustrations of the Casino and other attractions. The article offered an in-depth look at the "typical" middle-class family lured to the city and a detailed description of its early twentieth-century delights.[52]

According to the *Times* article, which followed a mythical middle-class patriarch and his family through their Asbury day, the father woke his family at an "ungodly earliness" to catch the early train—"for to the ease of his thrifty soul not a minute of the enjoyment must be lost." After the hurried buying of tickets and the trip to Asbury Park (an eighty-minute train ride from New York), the father found himself in the lobby of a sizeable hotel "with the large sense of having a lot of time on his hands to do with exactly as he pleases."[53]

The first stop for our family, of course, was the beach and boardwalk, where numerous shops offered children a cornucopia of treats, from buttered popcorn to colorful postcards of Asbury's many sights and attractions. Clearly, Bradley's decades-long fight to keep the boardwalk free of distracting amusements had been a losing one, and boys and girls were no doubt mesmerized by the variety of rides, from merry-go-rounds to toboggans. On the ocean side, a cluster of small fishing boats drifted lazily in the water, while passing steamships left trails of smoke drifting across the horizon in the

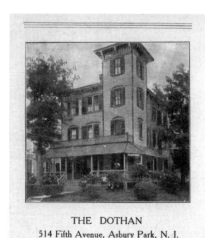

A Dothan Hotel advertising card, early twentieth century. *Courtesy Asbury Park Library.*

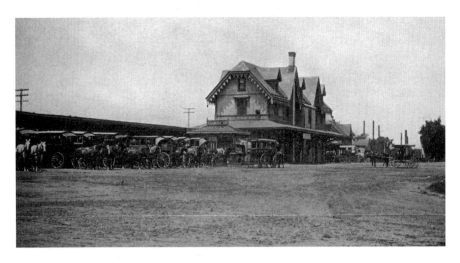

Asbury Park train station, circa 1900. *Courtesy Anne Ryan.*

distance. Of course, the main attraction of Asbury Park was the beach and the ocean, which, according to a travel writer, brought "healing and rest and change and exercise and health to the multitudes." And so the work-weary patriarch, in an updated imitation of James A. Bradley's earlier epiphany, led his clan onto the beach, where he dropped "to the hot sand, quite content to feel the heat." Looking around, he appreciated "the businesslike demeanor of the lifeguards perched in their stations, with shade hats protecting their already blackened necks…their eyes gazing sharply over the waves." The *Times* article's hypothetical paterfamilias's attention soon drifted, however, to some of the fashionable young women on the beach, particularly a nonchalant girl whose brown swimsuit matched the dark color of her tanned skin. She ran vigorously into the water, crashing through a big wave before swimming out to the farthest pole where the life ropes were fastened. This confident young woman compared favorably to some of the other female specimens our man espied on the beach, including a simpering young miss who persistently tried to catch the gaze of a lifeguard and another pretty girl who surrounded herself with boys and refused to go in the water.[54]

Young men were also out in numbers on the beach, our correspondent observed, concluding that Asbury Park proved a paradise for the American male "about 17 or 18 or 19 who has learned everything and…gotten hugely bored with it." During the day, these adolescent Romeos, no doubt to the distress of the aging James Bradley, flocked around the prettiest girls at the beach and at night roamed the boardwalk and hotel lobbies. According to the *Times*, it was the children who had the most fun at Asbury, with their "panties

James A. Bradley, the Founder

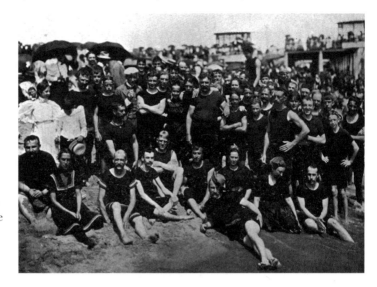

Bathers ready for a dip in the surf at Fifth Avenue, circa 1900. *Courtesy Anne Ryan.*

rolled way up, skirts tucked up above them, perhaps a bathing suit of ridiculous dimensions, hat off, and hair tousled and glinting in the sun."[55]

For the "typical" father lolling on the beach, all of these sights made up a mosaic of diverting hubbub that wafted him away from thoughts of the drudgery of work. Following a quick, strenuous dip in the ocean, he could opt for the less demanding waters of the city pool, where he could give swimming lessons to his children. After an entertaining day at the beach and a hearty lunch, afternoon diversions included a walk into the somewhat stricter confines of Ocean Grove, "where you must now take with you your own supply of chewing gum, as if you were going to a far, unheard-of country. For it is so like chewing tobacco that the trustees forbid its sale." Asbury evenings inevitably ended with a promenade along the boardwalk, where fashion-conscious visitors had the chance to model the latest styles and catch up on the most recent gossip. And eventually, lulled by the insistent pounding of the ocean and coolness of the night air, our "typical" father and family, and the thousands like them, headed back to their hotels and "took to their beds with the sound of the surf in their ears."[56]

As the opening decade of the twentieth century continued to unfold, Asbury's entertainment sector expanded even further. Coney Island entrepreneur George Tilyou established a fun house amusement center called Steeplechase Amusements in Asbury in 1913 in direct competition with the veteran Asbury Park impresario Ernest Schnitzler. Tilyou used a rather bizarre caricature of his brother as a brand logo, popularly dubbed "Tilley." Although his establishment is long gone, Tilley has stood the test of time as an Asbury icon.[57]

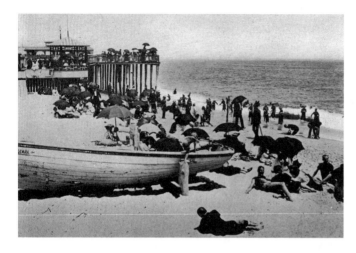

Beach visitors sunbathing at the Fifth Avenue beach at the turn of the twentieth century. *Courtesy Anne Ryan.*

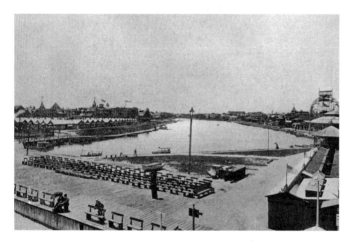

Wesley Lake, as seen from the boardwalk, with Ocean Grove on the left, early twentieth century. *Courtesy Anne Ryan.*

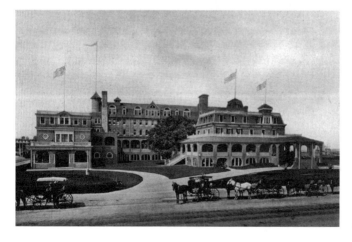

The Coleman House was the most popular hotel in Asbury Park in the early twentieth century. *Courtesy Anne Ryan.*

James A. Bradley, the Founder

The Adrian Hotel was typical of smaller hotels around the turn of the twentieth century. *Courtesy Asbury Park Library.*

The merchants who brought new life to the boardwalk then hired Harold B. Ayres, a slick publicity man, to promote the new-and-improved Asbury Park. Ayres bumped Bradley as baby parade promoter and solicited baby food manufacturer H.J. Heinz to replace him as titular head of the parade. After establishing new boardwalk policies, the city's leaders brought about radical changes in the governance of Asbury Park, changes that would move the city far beyond the Bradley years. The most significant of these was the annexation of West Park, which was proposed on the basis that it would provide a dramatic increase in tax revenues to bolster the city's coffers. What went unmentioned was that the annexation would also drastically change the Asbury electoral demographic. In his last significant attempt to seriously influence matters in his former colony, Bradley conceded that the northern part of West Park, the residence of many of the town's Jewish merchants, should become part of the city, but he opposed annexing the Springwood Avenue section "because of its class of voters."[58]

Bradley's opponents turned his argument around, maintaining that the annexation of the Springwood neighborhood would actually morally uplift the voters on that side of town; they set the stage for cleaning out the red-light, gambling and saloon districts that thrived there, largely due to patronage of people who visited Bradley's Promised Land on the east side of the tracks. Even though this position was championed by, among others, an Ocean Grove minister, the purity of its adherents' motives may be questioned—with West Park voters a significant factor in Asbury Park elections, the town's alcohol prohibition was surely doomed, and hotels would eventually open bars and increase both patronage and profit. Once started, there was no stopping annexation. City council president James

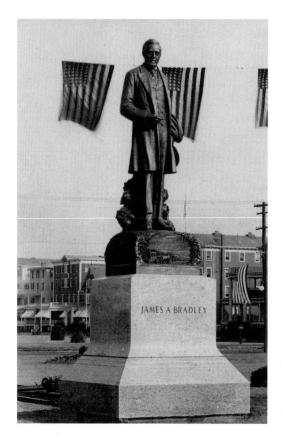

The statue of James A. Bradley, erected in 1921 within weeks after his death, at the time of its dedication. *Courtesy Asbury Park Library.*

D. Carton appointed a special committee of prominent citizens with instructions to use its influence to bring out a big pro-annexation vote. Bradley, who became a figure of fun to some during the controversy, led the opposition. He was trampled by the merchants' vision of the future when the vote was held on May 15, 1906. Annexation won out, 838 votes to 387. The Founder had lived too long. His dream was done (although he would survive another fifteen years and pop back into the news occasionally, most notably in his last, halfhearted stab at the beer ark men in 1911), and he was well on his way to a final role as a statue commemorating Asbury Park's past, eulogized but disregarded. In the end, he said, "I would have been much happier in my old age had I never heard of the place."[59]

And so, as James A. Bradley slipped into his long twilight and Asbury Park began to evolve into a business center, as well as a more "modern" resort, another figure appeared on the scene. Clarence E.F. Hetrick was a new and radically different man for the new century. And he would dominate it as surely as Bradley had the old one.

THE HETRICK YEARS

A NEW MAN IN TOWN

You can't discuss the Asbury Park story in the three decades following 1910 without mentioning Clarence Eugene Francis Hetrick, any more than you can talk about the city's previous forty years without referring to James A. Bradley. Both men were outsize personalities who dominated their Asbury eras for better—and sometimes worse.

Clarence Hetrick was not a native of Asbury Park, Monmouth County or even New Jersey. He was born in Van Wert, Ohio, on August 1, 1873, where he grew to adolescence and earned the nickname "Toad." In 1887, the Hetrick family reversed the overall nineteenth-century American "westering" trend and moved east to Monmouth County. Clarence, a precocious and ambitious young man, was the first student from the county to win an academic scholarship to Rutgers University, graduating in 1895. Initially employed in his father's Asbury Park real estate firm, Clarence took over the family business following the elder Hetrick's death in 1899. In 1906, he solidified his position in the community by marrying Ida Wyckoff, a member of an old New Jersey and Monmouth County family. An active participant in local Republican politics, Hetrick was elected tax collector of Neptune Township in 1904. A reputed fiscal whiz kid with a knack for reducing municipal debt, he subsequently served as Asbury Park treasurer following the city's 1906 absorption of the West Park section of town, where he lived.[60]

Hetrick parlayed his growing political experience and popularity into election as Monmouth County's sheriff in 1907, despite rumors that he had a mistress who was a laundress at the Keystone laundry, and it was

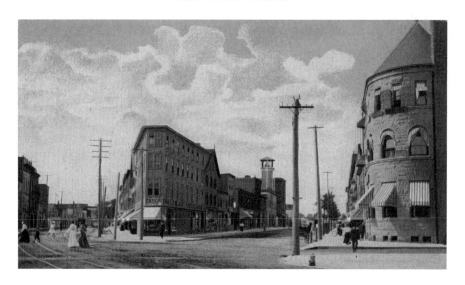

Cookman and Mattison Avenues, circa 1900. *Courtesy Asbury Park Library.*

Asbury Park Post Office on Cookman Avenue as seen from Lake Avenue, circa 1900. The building still stands. *Courtesy Anne Ryan.*

in this position that his display of personal and moral courage in dealing with a local tragedy and its aftermath secured his future Asbury Park political career. Ten-year-old Marie Smith, a white girl, went missing near Asbury and Ridge Avenues on her way home from the Bradley school in November 1910. A massive search involving police, schoolboys and National Guardsmen was launched, and rumors flew, including that she might have been abducted by Gypsies then camping at nearby Ardena. A $200 reward for information on Marie's whereabouts went unclaimed. When her battered body was discovered several days later, Thomas Williams, a black handyman who worked for the girl's aunt, with whom Marie and her parents lived, was arrested on suspicion of being her murderer. Williams, also known as "Black Diamond," strongly protested his innocence but was incarcerated in the Asbury Park jail. Shortly afterward, a mob began to form, and there was considerable talk of a vigilante solution to the crime. The only post–Revolutionary War New Jersey lynching had occurred in Monmouth County in 1886, when Samuel Johnson, alias "Mingo Jack," a black man and former jockey accused of raping a white woman, was hanged in the Eatontown jail doorway by a drunken vigilante mob. No one was ever prosecuted for Johnson's murder. Given that some men in the crowd milling outside the Asbury Park lockup bragged that they had been part of the Johnson lynch party, Sheriff Hetrick and Asbury Park police chief William H. Smith were understandably nervous and bolstered security. Hetrick himself holstered a handgun to help protect the prisoner and then, "thwarting a surging mob of would-be lynchers armed with sledgehammers, axes, crowbars and other jail-breaking implements," secretly transferred him to Freehold for safekeeping shortly afterward.[61]

Frank Heidemann, a German immigrant employed by Asbury Park florist Max Krushka, was also considered an initial suspect in the Smith murder, since he had been spotted peeking over a fence at the girl while she was playing. Heidemann was arrested shortly after Williams but released three weeks later for lack of evidence. On December 2, a Monmouth County grand jury found that Marie "had met her death at the hands of some person unknown to this jury" via a blunt instrument. The jury could not conclude whether the girl had been sexually molested. Despite the verdict, the still-incarcerated Williams remained the prime suspect. Black Diamond's case was not helped when Martha Coleman, a "young colored woman," testified that "she had heard Thomas Williams, a negro, say there was a little white girl at Mrs. Jackson's [Marie's aunt] whom he intended to possess."[62]

A local newspaper pronounced Williams guilty without benefit of trial, citing as evidence an incredible chain of racist logic that "criminal assault plainly was the motive for the crime. This is a negro crime. 'Black Diamond' was the only negro known to have been near the scene at the time the crime was committed." Hetrick remained unconvinced of Williams's guilt, however. The sheriff thought Heidemann, who left town shortly after his release, was the real murderer. Along with some respected citizens who agreed with his conclusion, the sheriff hired the Burns Detective Agency to investigate the case, much to the dismay of the local police. Hetrick's judgment eventually proved correct. In March 1911, an undercover Burns private detective who had befriended the unsuspecting German and traveled around the country with him "wormed" a confession out of the gardener, following an elaborate ruse that took months to construct. Monmouth County detective Elwood Minugh apprehended the suspect on a Jersey Central train between Atlantic City and Jersey City. Heidemann was removed from the train at Red Bank and hustled into Sheriff Hetrick's waiting car. The citizens of Asbury Park were "greatly stirred up" by the arrest and his subsequent trial, conviction and execution. Sheriff Hetrick's efforts in clearing Thomas Williams were not forgotten by Asbury's West Side African American community, which delivered a landslide vote for him when he ran for Asbury Park city commissioner in 1915 and was subsequently elected mayor by his four fellow commissioners.[63]

For the rest of his life, Clarence Hetrick was intimately associated with Asbury Park politics and for most of those years was the city's mayor. He began his political career as a Progressive Republican and Theodore Roosevelt supporter and even broke temporarily with the party to become a Bull Moose adherent in 1912 when Roosevelt ran unsuccessfully as an independent. The mayor eventually became chairman of the Monmouth County Republican party and a state Republican committeeman. He quickly proved to be an energetic city leader. Soon after assuming office, Mayor Hetrick consulted with Baltimore fire chief August Emrich, who led the "most up-to-date and efficient fire department in the country," on creating a professional-quality fire department in Asbury Park. He provided board of health support, encouraged donors to a child welfare home, paved streets and built a new high school. Hetrick was also an early champion of women's suffrage, appointed A. Grace King as the first female city clerk and later school board administrator and opened up other city jobs to African Americans, Italians and Jews for the first time.[64]

Asbury Park had distributed printed tourist literature before. A 1908 brochure described the city as "the beauty spot of the North Jersey Coast"

The Antler Hotel and Restaurant on Lake Avenue and Main Street in the early twentieth century. *Courtesy Asbury Park Library.*

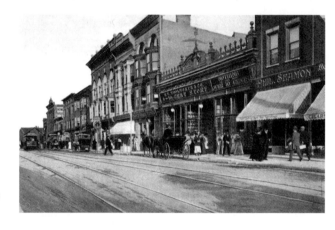

Cookman Avenue in the early twentieth century. *Courtesy Asbury Park Library.*

The original Asbury Park High School. *Courtesy Asbury Park Library.*

and "absolutely free of mosquitoes," and it alluded to the city's role as a growing commercial town. The new Hetrick administration, however, in conjunction with the city's chamber of commerce, quickly produced a brochure heavily promoting the city not only as a vacation destination but also as a regional light manufacturing, banking and retail location. J. Adrien Waterbury, president and district manager of the New York Telephone Company and chamber of commerce president, wrote that "Asbury Park is not only the greatest summer resort in the country, but…is an ideal place of recreation the year around, and an important business center." A pillar of that business was Steinbach's department store on Cookman Avenue, the "largest resort department store in the world." In a series of essays by prominent chamber members, the brochure touted the "town without a frown's" 250 hotels and boardinghouses, accessibility, "carnivals and entertainments" (most notably the baby parade), transportation, athletic fields, fresh- and saltwater fishing and boating opportunities and tied a glowing vision of Asbury Park's future to that of New York City, for whose residents it was portrayed as a "logical playground."[65]

Asbury promised all this and good progressive government, too! In a separate essay, Mayor Hetrick added to the city's claim that it was a thoroughly modern municipality by noting that in 1914 Asbury Park had adopted the "newest and most approved mode of non-partisan Commission Government" and assured his readers that future governance would follow a "successful corporate business" model. James A. Bradley, who was still alive,

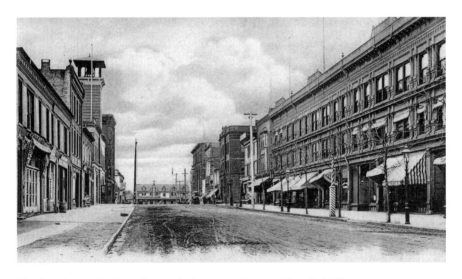

Mattison Avenue in the early twentieth century. *Courtesy Asbury Park Library.*

received but a small back-of-the-book blurb advising that he still had an interest in Asbury Park but was selling and leasing land in nearby Bradley Beach. Those interested were directed to apply to his agent. The new era had fully dawned.[66]

There would be a few bumps along the road to unending progress for some Asbury Park residents. Company H of the Third New Jersey Infantry Regiment, successor to Company A as the city's National Guard unit, was called to active duty on June 19, 1916, in response to Mexican revolutionary Pancho Villa's incursion into New Mexico. The Asbury Guardsmen reported to the National Guard camp at nearby Sea Girt and then proceeded to Arizona, where their regiment was deployed to guard the border. The company returned in the fall of 1916 but was soon called back to active service with the outbreak of World War I. From Sea Girt, the Jersey soldiers proceeded to Anniston, Alabama, where, along with National Guardsmen from Virginia, Maryland and the District of Columbia, they became part of the Twenty-ninth Division. The division later fought in France in the Meuse-Argonne Offensive of 1918. Only one city resident, Harold Daly, died in the service, but the war brought some dramatic temporary changes to Asbury Park, as the city's hotels and boardinghouses became transitory homes for hundreds of war workers with jobs in Perth Amboy, Elizabeth and other New Jersey municipalities with limited available housing. Special trains with reduced war worker fares ran the tracks of the New York and Long Branch railroad daily. Mayor Hetrick did his bit for the war effort as well, serving as a membership drive chairman for the Red Cross and chairman of the First Liberty Loan Drive, among other public service positions. As America entered the war, Hetrick had to deal with his first local crisis as well, when an April 5, 1917 fire attributed to defective electrical wiring broke out at the "Natatorium," an indoor boardwalk swimming pool and, whipped by a fifty-mile-per-hour wind, swept west into the city. Four blocks full of hotels were burned to the ground, along with the Methodist church on Grand and First Avenues, for a total property destruction estimated at over $1 million. The following morning, Hetrick's government announced that it was going to accept bids to rebuild the Natatorium "at once."[67]

In stark contrast to Bradley, Hetrick was an anti-Prohibitionist, and one older resident who remembers him well recalls that her family and friends loved the mayor because he was "into civil rights and a 'wet' Republican." Hetrick's "wet" stance evoked the ire of the members of the Anti-Saloon League and Asbury Park's "Civic Church League," who saw James A. Bradley's original ideal of a "dry" middle-class family resort rapidly waning as the civic boosterism represented by Hetrick and his friends

Left: Captain Harry Harsin was a lieutenant in Asbury Park's Company H, Third New Jersey Infantry, before World War I. Called to active duty with the unit, he served in the Twenty-ninth Division and rose to the rank of captain. *Courtesy National Guard Militia Museum of New Jersey/Sea Girt.*

Below: The Asbury Park National Guard Armory. Built in the early twentieth century, the armory saw troops off to the Mexican border in 1916, World War I in 1917 and World War II in 1940. After the war, it was also used for sporting events and eventually became a Veterans of Foreign Wars (VFW) post. *Courtesy Asbury Park Library.*

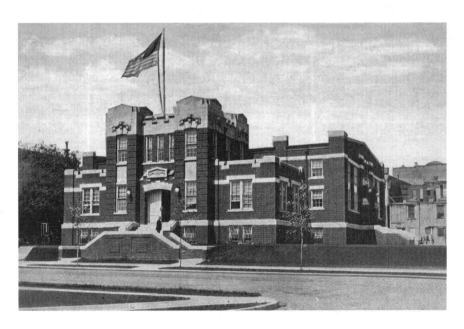

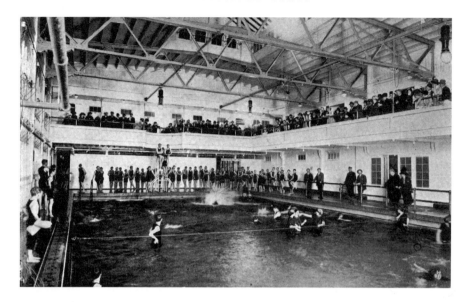

The interior of the Natatorium, destroyed by fire in the great conflagration of 1917 and rebuilt. *Courtesy Asbury Park Library.*

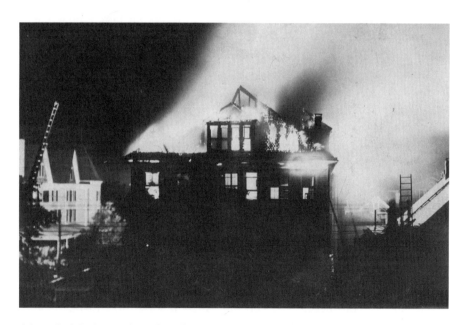

Asbury Park had many hotel fires. In this one, the Hotel Carleton burned in 1915. It was rebuilt the following year, only to burn once again in the great fire of 1917. *Courtesy Asbury Park Library.*

seemed to promise a honky-tonk future for the city. Although the old man was still alive following the end of World War I, Hetrick initiated a steady campaign to relax and gradually abandon Bradley's strict ordinances. In 1919, the mayor introduced legislation to permit movie theatres to open on Sunday and subsequently made a comment that Asbury Park and its people were no better or worse than those of any other city. To many of the faithful, the Promised Land of the nineteenth century seemed well on the way to abandonment.[68]

THE KU KLUX ATTEMPT A COUP

One could, of course, argue that the Civic Church League's Promised Land had never been much more than a façade. By the time the rest of the nation caught up to Bradley's ideal of alcohol prohibition with the 1919 passage of the Volstead Act as enforcement legislation for the Eighteenth Amendment, Asbury Park imbibers had already pioneered ways to skillfully evade it. In addition to stopping a rumbling beer ark, you could, of course, patronize a speakeasy on Kingsley Street or whisper a word to your family pharmacist for a cure for overpowering thirst in Asbury as early as the 1880s. The new national prohibition would not alter that activity, and illegal drinking establishments continued to thrive, disregarded even by the city's elected leadership, who, according to one recollection, patronized a speakeasy called Ross and Fenton's Farm across Deal Lake in Wannamassa, where there was "gambling, drinking and dancing." Much to the delight of Asbury Park's white population, African American watering holes on Springwood Avenue that provided good modern music and liquor flourished, although they were subject to the occasional raid for publicity purposes. There were more potent drugs than alcohol available in Asbury Park in the early twentieth century as well. In 1913, two young men, James Poland and Floyd Megill, were arrested in Newark for possession of "heroin tablets." Both men, former Monmouth County residents, told police that they had become addicted to heroin in Asbury Park, buying it from a city resident they knew only as "Doc," and further stated that "there were many others in that city addicted to the use of cocain [sic] and heroin." Seven out of eight men brought before that Newark judge in 1913 testified that they had become addicted to narcotics in Asbury Park.[69]

Methodist hopes to the contrary, Asbury Park had, in fact, turned into a pretty tough town, where you could find trouble if you were looking for it, and you didn't have to look too far. On July 19, 1919, John Vacchiano

walked into Vetrano's Ice Cream Parlor on Springwood Avenue and, after a brief conversation with Nunzio Crispo, ended his feud by shooting Crispo to death in front of Crispo's six-year-old daughter. The reason for the bad blood between Crispo and Vacchiano was unclear, although it appears that Crispo, a junk dealer, had sidelines as a bookie and a loan shark, and an unpaid debt may have played a part. Elmer Stockton Vaughn also came to a bad end in "the town without a frown" in September 1920. Vaughn, a movie projectionist for Asbury Park theatres and member of a faux Hawaiian song-and-dance act appearing in a Kingsley Street vaudeville house, ostensibly left his Ocean Grove residence late one afternoon to buy some dinner rolls but never returned home. He was stabbed by one Fred Martin in an altercation on the corner of Springwood Avenue and Main Street and died in the Asbury Park hospital early the following morning. Accounts from witnesses varied. Some stated that Vaughn may have been intoxicated and gambling with Martin and four other men, but family members vigorously denied that account. He left a widow and four sons.[70]

As the pace of everyday life in Prohibition-era America quickened during the breathless 1920s, so did the tempo in Clarence Hetrick's increasingly sophisticated Asbury Park. Thanks to its location on the Jersey Shore, the resort was a popular destination for young "flappers" and "sheiks" who defied national alcohol prohibition as flagrantly as they had the local brand and caroused on the city's West Side. Motorboats filled with crates of illegal hooch trawled the waters off the Jersey coast, providing plenty of liquor for thirsty vacationers in search of good times. And there was jazz, which flourished in the clubs and speakeasies up and down Springwood Avenue. Although nationally known bandleader Arthur Pryor, Asbury Park's official music director, had embraced and "covered" ragtime the decade before, turning out his own version of the music pioneered by black composer Scott Joplin, he bristled at the new African American sound and predicted its early demise, "unwept, unhonored and unsung." Pryor did not take into account brilliant young musicians like Red Bank–born William "Count" Basie, who had heard Duke Ellington play at a Springwood Avenue club before World War I and instantly knew his life's work. Basie's first stop on his way to worldwide fame was Asbury Park, where he performed at West Side clubs and roadhouses on the edge of town.[71]

Outrage by many at the seeming moral laxness of the era presented Hetrick's opponents in the Civic Church League a window of opportunity to disgrace and perhaps unseat the mayor. To further its ends, the league allied itself with the Ku Klux Klan. The Klan, a long-disbanded association of hooded nightriders associated with the unruly aftermath of the Civil War,

was reborn a few years after Mayor Hetrick saved Black Diamond. By 1924, the organization was on the rise in a nationwide contemporary incarnation, and Monmouth County would provide it with a New Jersey homeland.

The Klan's story of rebirth began in Georgia on a stormy Thanksgiving night in 1915. William J. Simmons, a thirty-five-year-old former itinerant Methodist preacher, defrocked due to "inefficiency and moral impairment" and turned fraternal club organizer, led a small band of followers up a 1,700-foot granite escarpment north of Atlanta. Once atop Stone Mountain, Simmons set a cross ablaze and pronounced the rebirth of a secret militant organization originally dedicated to restoring the *status quo antebellum*—white economic, social and political hegemony without actual slavery—in the post–Civil War South. The new Klan's founder styled himself as "Imperial Wizard" of an "Invisible Empire." Self-promotion and hyperbole were not new to "Colonel" Simmons, who implied that his Woodmen of the World fraternal rank was a military one, though he never rose above private during a short stint of stateside Spanish-American War service. The suddenly newsworthy Simmons told a reporter that the revived Ku Klux Klan "resembled the old one in having the same spiritual purpose but a different material form; the same soul in a new body," but the Imperial Wizard's organization, after he ceded actual control of it to others, would actually grow to far exceed the original order's nightriding Confederate veterans in membership, geographic spread and target selection.[72]

The retooled Klan's message of "one hundred percent Americanism" combined visions of patriotism, comradeship and the security of belonging to something bigger than oneself, with an appeal to ceremonies based loosely on those of other secret fraternal orders, from the Masons to the Patrons of Husbandry to the Grand Army of the Republic, which had proliferated in nineteenth-century America, with the extra added attraction of costumed parading. The new Ku Klux Klan considerably broadened its predecessor's enemies list to include not only "uppity" African Americans and their white political allies, but also immigrants, Catholics and Jews, all perceived as threats to the hegemony of native-born white Protestant Americans. It subsequently added Communists, labor unions and anti-prohibition "wets" to the list as well. Anti-immigrant organizations were nothing new in America, with predecessors including the "American" or "Know-Nothing" political party of the pre–Civil War era and the Order of United American Mechanics, created as an anti-Irish-Catholic fraternal association in the 1840s. The Pennsylvania-based Junior Order of United American Mechanics, which convened and paraded in Asbury Park before writer Stephen Crane a generation earlier, became the leading anti-Catholic and

anti-immigrant organization of its type by the 1890s, with the xenophobic American Protective Association a close second. Spasms of hostile behavior, often featuring violence against both Asian and European immigrants, were recurrent events in nineteenth-century America, and they waxed and waned over the years. The hyperpatriotism and paranoia generated by government propaganda during World War I, however, followed by fears of a Bolshevik revolution and the resultant "Red Scare," along with a general perception of a postwar breakdown in morality, no doubt helped create an atmosphere that enabled the 1920s-era Ku Klux Klan to flourish and become the largest and most influential group of its type in American history.[73]

The August 1915 lynching of Leo Frank, an Atlanta pencil factory superintendent and convicted murderer of thirteen-year-old Mary Phagan, helped create a climate for Klan revival. Although some doubts were raised as to his guilt, Frank, a Jew, was lynched by an ad hoc group of vigilantes who dubbed themselves the "Knights of Mary Phagan." In a similar manner, the release of D.W. Griffith's feature film *The Birth of a Nation*—which portrayed gallant Klansmen rescuing post–Civil War white Southern women from harassing, lecherous African American freedmen portrayed by white actors in blackface and garnered the endorsement of Southern-born former New Jersey governor and then president Woodrow Wilson, who termed it "terribly true"—added fuel to the fire. Even though these events created a favorable public predisposition toward the rebirth of the Klan, Simmons's new band of hooded heroes did not spread much beyond the greater Atlanta area until Edward Young Clarke and Elizabeth Tyler, who styled themselves as "the Southern Publicity Association," appeared on the scene. Clarke and Tyler began to advertise the Klan nationwide, characterizing it as a vehicle for promoting "one hundred percent Americanism" and the Protestant religion in the face of an alien tide. In return, the couple received 80 percent of new membership dues and other Klan profits. As dollar signs danced in their heads, Clarke and Tyler's recruiting program spread the Klan across the nation, including the Garden State.[74]

New Jersey provided a potentially fertile field for Klannishness. The state had been a nineteenth-century battleground between the increasing numbers of mostly Catholic immigrants that poured into its northeastern urban areas—20 percent of New Jerseyans in 1920 were foreign born—and an old-line Protestant small-town and rural majority. Nineteenth-century religious and political battles left a strong residual anti-Catholicism among large segments of the non-Catholic population, making the renascent nativist program of the Klan particularly appealing. One long-remembered controversial incident occurred in 1875, when, in response to policies

limiting Catholic clergy access to juvenile offenders, an Essex County assemblyman introduced church-sponsored legislation to create a "Catholic Protectory" or reformatory for errant Catholic youth run by the church with public funding. The bill roused Protestant opposition statewide, failed to pass and was the cause of many supporting legislators losing their seats in the subsequent election.[75]

Other religious battles involved Catholic protests over readings from the King James Bible in public schools; to Catholics, the "separation of church and state" came to mean separating their religion, while Protestantism, in all of its varieties, was enshrined as a semiofficial state creed. In fact, Protestant Christianity was pervasive in the entire public school curriculum of the day. One contemporary social commentator wrote that "the Geographies of the 1870s, and on to later than 1900, were serenely confident about the inferiority of religions other than [Protestant] Christianity." The curriculum of Phillipsburg High School in the 1870s included a block of instruction on both Old and New Testaments and "Biblical Geography." New Jersey was not unique in this struggle. In response, Catholics across the country agitated for publicly funded parochial schools, which sparked fierce opposition. The battle for prohibition of alcohol, a cornerstone belief of many New Jersey Protestants, particularly Methodists, was another friction point, as most Catholics were working-class "wets." This history of religious and ethnic antagonism may well have been responsible for the large number of Protestant ministers who actively supported and even recruited for the Klan in the 1920s.[76]

The Klan made its first public appearance in New Jersey in the summer of 1921, as Garden State Klansmen began to don hoods and follow the lead of newly minted Klan members in Pennsylvania and New York. Klan leaders soon proclaimed that the order had spread to cities and suburban and rural townships across the state. In actuality, it appears that while some early Klan chapters (like Leif Ericson Klan Number 1 in Paterson) were located in urban areas, the organization's core strength initially developed in suburban towns surrounding cities with large immigrant populations, like Bloomfield, which bordered on Newark and was home to the state's Grand Dragon, Arthur Bell. Two years later, a newspaper survey of Klan activity in New Jersey revealed that while membership was thought to be widespread, there was little overt Klan activity. An early 1923 report from Asbury Park noted that the Klan had "never shown any public signs of activity here, although it is believed several local people are members of it." That Memorial Day Klansman showed up to lay "a cross of roses bearing the letters K.K.K." at the Neptune World War I memorial outside the Ocean Grove gates, a

practice that would continue for a number of years, but there was little outward Klan presence in any other shore communities.[77]

Klan activity would become much more public the following year. As Bell expanded his organization southward into central New Jersey, he discovered ambivalence and more. Somerset County evangelist Bishop Alma White embraced the Klan and encouraged the adherents of her "Pillar of Fire" church to join the organization. When Pillar of Fire holy rollers tried to expand Klan membership in nearby Bound Brook in the spring of 1923, however, they found themselves besieged by rock-tossing townspeople and had to beat a hasty, police-protected retreat to their refuge in Zarephath. Some Middlesex County municipalities proved somewhat hospitable to Bell's Klansmen, but a Klan rally in Perth Amboy incited a riot from which the participants barely escaped with their lives.[78]

Testing the waters yet farther south, Bell finally found a membership gold mine in Monmouth County. Long Branch, formerly the sin center of the Jersey coast, was surprisingly welcoming. Klan leadership purchased Elkwood Park in that city and, on July 2, 1924, held a tri-state "Konklave" on the property that featured intra-Klan sporting events and culminated in a huge hooded parade on July 4. Many of the devout and "dry" Methodists of Ocean Grove, as might be expected, were susceptible to the message of the robed moralists. There was public interest in Asbury Park despite, or because of, its large Jewish, Italian-Catholic and black population. Long Branch and the banks of the Shark River in Wall Township, as well as nearby Point Pleasant in northern Ocean County, not only supplied numerous Klan members but also became welcoming destinations for vacationing Klansmen and their families.[79]

Once it was clear that Monmouth and parts of Ocean County were fertile fields for promoting "one hundred percent Americanism," Grand Dragon Bell quickly went to work enlisting ministers as local "kleagles," or recruiters. At rallies at Clark's Landing in Point Pleasant, Ocean Grove's auditorium and other locations, Bell fired up anxious elements of the native-born white Protestant population with his standard stump speeches. He claimed that he had somehow discovered "eighty-seven thousand cases of white girls living with negroes and men of the yellow race" and described plots being hatched by Catholics and Jews to take over the American military and economy. Bell's wife, a helpmate in his crusade, was also den mother to the "Tri-K girls," a sort of Klan girl scouting organization that promoted the virtues of motherhood. Although Klan membership grew in Asbury among older residents nostalgic for the ideas of James A. Bradley, and the town's Protestant ministers warmed to the organization's message, Bell's antics began to

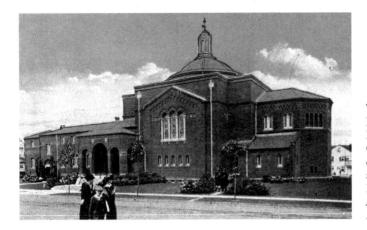

The Asbury Park Methodist Episcopal Church, site of a June 1923 anti–Ku Klux Klan riot. *Courtesy Asbury Park Library.*

receive an increasingly chilly reception in the city when it became evident that a Klan presence discouraged tourist traffic from northern New Jersey and New York. Despite this, a Maryland newspaper reported that on June 26, 1923, Reverend DeWitt Cobb, chaplain of the New Jersey State Senate, hosted a small local Klan parade at a Methodist church in Asbury Park. Reaction was swift. The paper noted that sixty Klan members marching to the church were attacked by a mob in a "free for all fight" and "several Klansmen were thrown to the street" before police separated them from the anti-Klan demonstrators. The Klan certainly got no support from Mayor Hetrick, who governed with the support of African American, Catholic and Jewish voters and the local business community.[80]

Clarence Hetrick was not only mayor of Asbury Park but also president of the city's chamber of commerce and the biggest booster of Asbury's transformation into a modern resort and local economic center. It was his involvement with the Asbury Park business community that provided an opportunity for the Klan, allied with the Asbury Park old guard, to attempt a coup that would remove him from office on charges of immoral activity. In the spring of 1924, the mayor attended the city's annual business show, a small trade fair with one hundred exhibitors dedicated to advertising and expanding the growing consumer-oriented retail economy of the 1920s, held at the boardwalk casino. On the evening the show closed, the mayor enjoyed a "dinner and cabaret entertainment" at the Deal Inn with leading Asbury Park and Monmouth County merchants and political leaders. Following the event, Walter Tindall, an Asbury Park printer who attended, claimed it had turned into an orgy in which he had refused to participate. Tindall was likely one of the "several local people" previously reported as covert Klansmen, and his statement instantly galvanized the Civic Church League and the Ku Klux Klan against the mayor.

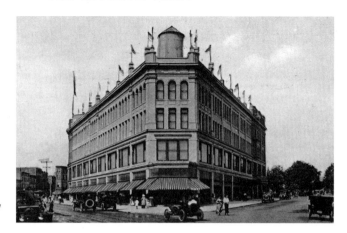

Steinbach's department store, the "largest resort department store in the world," in the 1920s. *Courtesy Asbury Park Library.*

According to Tindall's affidavit, there "was much drinking" at the affair, and "five women imported from New York gave an improper display."[81]

Hetrick and his dining companions were instantly attacked from Klan headquarters in Long Branch, where Ku Kluxers immediately convened a meeting to organize a committee to begin "cleaning up the coast resort cities." There seemed to be close coordination between the pronouncements of the Klan and the Asbury Park clergy, as the "orgy" was simultaneously damned from Protestant pulpits across Asbury Park. On April 6, the ministers placed a notice in the *Asbury Park Press* advertising that the city's ministers would roundly condemn the Deal Inn party at church meetings that evening, using the Tindall affidavit as the basis of their sermons. Methodist pastor Reverend Furman A. De Maris, who admitted that he had conferred with Klansmen before orating on the matter, vowed that "if only one-tenth of the charges made in this affidavit are true, it would be time to take drastic action." De Maris welcomed Klan support to "clean up" the city. Baptist minister David A. MacMurray opined that political officeholders attending an event at which "whiskey, champagne and beer flowed" and where the "entertainment was characterized by lewdness" should be driven from office. The clergymen submitted Tindall's affidavit to the county prosecutor for grand jury presentment.[82]

Hetrick vigorously denied the accusations. The mayor firmly stated that "any allegation to the effect that nude women were present is a lie pure and simple" and emphatically declared that "the charge that a nude woman sat on my lap is a damnable lie." In the event, the charges collapsed when no one corroborated Tindall's accusations, and he was revealed as an apparent bankrupt Klan puppet of Arthur Bell. Tindall's account was summarily dismissed by a county grand jury, and he was charged with perjury himself. The mayor's triumph broke the back of the Klan in Asbury Park.[83]

By August 1924, the Klan drew more condemnation in Asbury Park as a reporter interviewed the vacationing Thomas Dixon, author of the *The Clansman*, the novel on which D.W. Griffith's epic was based. Dixon, then living in New York on the considerable fortune he had garnered from book and film, unhesitatingly condemned the new Klan as "a growing menace to the cause of law and order." The author, who said he had refused an offer to join the organization, also characterized the Klan as a "menace to American democracy." Later that month, Democratic presidential candidate John W. Davis, who had previously been ambivalent regarding the Ku Klux Klan, gave an anti-Klan speech while visiting Governor George S. Silzer at New Jersey's summer capital at the Sea Girt National Guard Camp, in the heart of the Klan's shore stronghold.[84]

The failure of the Klan power grab in Asbury Park did not toll its death knell in the rest of New Jersey and Monmouth County, however. Klansmen filled the galleries of the New Jersey legislature in an effort to influence the passage of a bill demanding Bible readings in the state's public schools and opposed United States senator Walter Edge in the 1924 Republican primary. Edge was deemed insufficiently "dry" by the organization's leadership. He went on to win the nomination and reelection in spite of the Klan, in another blow against Klan interference in the state's political process. Exercising its regional muscle, however, the Klan did manage to defeat World War I veteran Major Stanley Washburn, a Republican congressional primary candidate in a district including Monmouth, Middlesex and Ocean Counties who refused to fire his Catholic secretary and old war buddy. Frederick W. Vanderpol, a well-known songwriter and singer, who later succeeded Arthur Pryor as Asbury Park's "municipal director of music," ran unsuccessfully for the Republican nomination for state assembly on an anti-Klan ticket and reported receiving death threats from anonymous Monmouth County Klansmen.[85]

Still, the Klan was tottering nationwide at mid-decade as opposition hardened across the country. The New Jersey and national Klans began to implode from internal divisions, revelations of corruption and sexual scandals, including that of a Trenton minister and central Jersey kleagle who deserted his wife and children to run away to Texas with a neighbor's daughter and $1,000 in Klan funds. Even the merchants and citizens of the Klan stronghold of Long Branch, like those of Asbury Park, became alarmed at the decrease in Jewish and Catholic tourism and started to rethink their support. A number of Protestant clergymen, including a Methodist bishop, began to publicly attack the Klan as well. An anti-Klan minister in Atco who was denounced by a Klansman in his parish (the Klansman claimed that he dreamed that the pastor "was a false prophet and an advocate of free

love") threatened to shoot anyone who burned a cross on his lawn. In 1927, John Messler, a Methodist minister who was Grand Exalted Cyclops of the now-cowed Asbury Park chapter, resigned as a result of a series of internal lawsuits over Klan real estate ownership. More and more, things began to come apart for the Invisible Empire in New Jersey.[86]

The 1928 presidential campaign brought about a slight uptick in the Klan's generally down-trending fortunes. The national and New Jersey Klan's attentions, unsurprisingly, were drawn to attacking the candidacy of Alfred E. Smith, an anti-Prohibition Catholic with a multiethnic immigrant heritage, for the Democratic nomination. As part of the effort, Democrat senator James T. Heflin of Alabama toured New Jersey, lecturing on "Dangers that Threaten the American Government," chiefly the Catholic Church, at Klan gatherings across the state, including rallies at Woodbridge and Long Branch. Heflin's message, in which he apparently saw no irony, was decrying the danger of a "Roman Catholic political machine which is attempting to destroy free press and freedom of religious worship."[87]

Following a Long Branch lecture on July 22, Heflin holed up in the Monterey Hotel in Asbury Park, one of the city's classiest hostelries, where he publicly stated that his life was "in danger." In a display of paranoia surprising even considering Heflin's record—while a member of the House of Representatives he shot a black man for arguing with him on a Washington, D.C. streetcar—Heflin had the hotel clerk screen anyone who came to his room, including a carpenter sent to repair his defective bed. By that time, the senator's motives had come under scrutiny when a letter to an Asbury Park resident published in the *Asbury Park Press* revealed that the Alabaman's crusade of conscience was actually arranged by a sort of Klan speakers' bureau that charged $125 a day for his services.[88]

Despite Heflin's efforts, Al Smith got the Democratic nomination. And the New Jersey Democracy decided to figuratively poke the Klan in the eye in its Monmouth County heartland. On August 25, 1928, Jersey City mayor and Democratic Party boss Frank Hague and his political ally Governor A. Harry Moore engineered a massive rally for the Klan's worst nightmare at the Sea Girt summer capital, several miles to the south of Asbury Park. Over eighty thousand people, mostly from other areas of the state, showed up at Sea Girt, in what one newspaper characterized as the "greatest throng ever gathered in Jersey," to cheer on the candidate. That same day, Klan fellow traveler and famed preacher Billy Sunday, preaching at Ocean Grove, riposted that the election of Smith, "a Tammanyite, a Catholic and wet," would be "a national calamity." Although Smith was indeed trounced in the

The New Monterey Hotel on Kingsley Street opened in 1912. Senator James T. Heflin of Alabama stayed here in 1928 while on a KKK-sponsored speaking tour. More reputable guests included Al Smith, the Prince of Wales and Winston Churchill. The hotel owners went bankrupt after World War II, and the building was demolished in 1963. *Courtesy Asbury Park Library.*

election, as the decade progressed the Klan's excesses earned other New Jersey enemies as well, including the Atlantic City Elks and the state's American Legion commander. Statewide opposition—clerical, governmental and from vigilantes—grew, exacerbating internal divisions in the Jersey Klans, and in the end the organization even lost its Monmouth County jewel, the proposed resort on the banks of Shark River, through fiscal mismanagement. Although Arthur Bell would arrange a poorly timed meeting of the remnants of his Klan with the thugs of the German American Bund in the summer of 1941, the organization largely disintegrated in the early 1930s. As historian David M. Chalmers posited, "New Jersey was just not ready for the Klan." And Mayor Clarence Hetrick of Asbury Park, who ran in 1927 on a publicly announced anti-Klan platform, could take credit for getting the ball rolling to prove the point. The mayor was at the top of his game.[89]

As the Klan faded from the scene late in the decade, presidential scandal touched Asbury Park with the publication of a book entitled *The President's Daughter*. The president in question was Warren Harding, who had died in office in 1923. The author was Nan Britton, who alleged that Harding had fathered her out-of-wedlock child. Political insiders knew of Harding's proclivity for ladies other than his wife but kept that fact under wraps.

Meanwhile, the public had been barraged with a seemingly endless series of stories detailing scandals connected with Harding's administration, most notably the Teapot Dome affair in which Secretary of the Interior Albert Fall leased Wyoming oil fields set aside as part of a national strategic reserve to an oilman friend who "loaned" him a considerable amount of money. Lack of evidence of his own involvement in any of these affairs protected the personally popular late president's reputation, however. When Britton's tome hit the market, published by a hitherto-unknown firm, the Elizabeth Ann Guild Inc., many booksellers were reluctant to carry the book and media outlets failed to review it. These facts did not materially affect distribution and sales, however, and one prominent journalist of the era recalled that although the book's "circulation [was] some 90, 000," it was far more widely read than that figure would indicate. He reported that "probably never did a book have so large a number of readers in proportion to the number sold, for the volume was passed from hand to hand, was abstracted from a drawer of the desk in the sitting room to be read by adolescents away from the parental eye; or was devoured by eager-eyed servants in the absence of the family."[90]

Britton, an Ohio native born in 1896, wrote that she had become infatuated with the then middle-aged Harding when she was fourteen years old and papered the walls of her room with images of the local newspaper editor and politician. In the book, she admitted to stalking Harding, peeking in the window of his office at the *Marion* [Ohio] *Daily Star*. Britton went on to relate that after graduating from high school she moved to New York and wrote Harding, asking for his help in gaining employment. According to her, he responded affirmatively shortly afterward, and they then began a longstanding affair, which resulted in her delivery of his baby in Asbury Park in 1919. Although she claimed that Harding sent her child support money while he was alive, Britton was spurned by the president's family members after his death in office in 1923. And so, as the Roaring Twenties faded, Asbury Park came to play a small part in illuminating the cavalcade of corruption that helped seal Warren Harding's reputation as one of America's worst presidents.[91]

THE MAYOR FALLS FROM GRACE

Asbury would soon have more than a fair share of its own corruption tales. Although his other self may have been present all along, as the twenties waned, Clarence Hetrick as progressive reformer began to morph into Clarence Hetrick the political boss, and the result combined some of the worst

characteristics of nineteenth-century cronyism with a murky link to monopoly capitalism that would have shocked his old hero, Teddy Roosevelt. At first, Hetrick simply seemed to be expanding his long-proclaimed vision to make Asbury Park the tourist and commercial showplace of the New Jersey shore, if not the nation. When four old wood-frame hotels burned down in 1923, he encouraged the construction of the Berkeley-Carteret Hotel by a local investor consortium headed by the influential merchants of the Steinbach family to replace them. The Steinbachs contracted with well-known New York architect Whitney Warren to design a boardwalk pavilion and link it to the hotel.[92]

The former fiscal whiz kid mayor would give Warren a lot more city business. Following two "undetermined origin" fires in 1927 and 1928 that consumed the Fifth Avenue Arcade and the Casino at the south end of the boardwalk, Hetrick argued that Asbury Park needed a convention hall to compete with Atlantic City and awarded Warren a no-bid contract to design it and a new casino, both in Beaux Arts style. Warren and his partner, attorney Charles Wetmore, soon received even more city contracts, including a new municipal sewer plant and a heating plant to warm the waters of the boardwalk Natatorium and buildings, as the spiraling projects increased the city's bonded indebtedness by $4 million. Disregarding a protest from local entertainment mogul Walter Reade, who operated four theatres in Asbury Park, that including yet another one in the massive boardwalk development would flood a necessarily limited market, Hetrick promised that significant

The Berkeley Carteret Hotel, 1930s. *Courtesy Asbury Park Library.*

new city revenues would result from large boardwalk rental fees. Perhaps in anticipation of this windfall, in 1927 the mayor accrued significant additional city debt to build a new high school. Reade did end up leasing the boardwalk theatre, but his prediction proved correct, especially as a severe economic downturn began to develop following the stock market crash of 1929.[93]

For someone supposedly well tuned to financial trends, Hetrick seems to have missed the onset of the ever-deepening Great Depression. The Roaring Twenties and the mayor's financial splurge on borrowed money had provided, in retrospect, a symbol of the ephemeral flash of seemingly frantic pleasure coupled with ominous domestic threats that characterized American life between the disasters of World War I and the Depression. The economic collapse hit Asbury Park, largely dependent on people spending their spare cash, perhaps harder than the rest of New Jersey. There was no end to the good times for Mayor Hetrick and his cronies, however. Hetrick's expanding boardwalk building program had increased the total city debt to $15 million by 1930, and boardwalk lease fees to his friends were lower than ever. Probable kickbacks on those leases were not the only source of dubious money that the mayor was raking in. In the early 1920s, Hetrick assumed a vaguely defined private sector job as "confidential advisor" to financier Harley Clark, a principal of Utilities Power & Light, a huge electrical power conglomerate. As the decade came to a close, the mayor, who appears to have actually been a lobbyist for the conglomerate, was seldom seen by his

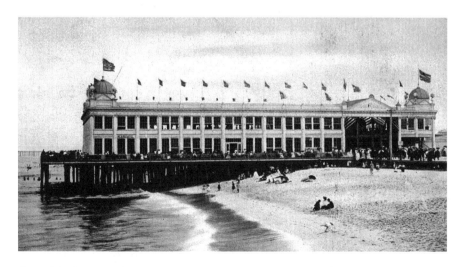

The original casino, erected by the city after the purchase of the beachfront from Bradley. It burned in a mysterious fire in the late 1920s and was replaced by a new Beaux Arts casino. *Courtesy Asbury Park Library.*

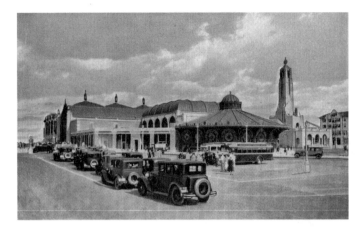

The casino and arcade in the 1930s. Mayor Hetrick's boardwalk heating plant is in background. *Courtesy Asbury Park Library.*

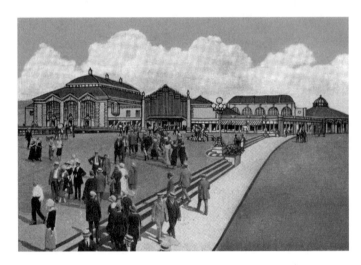

The casino and arcade in the 1930s. *Courtesy Asbury Park Library.*

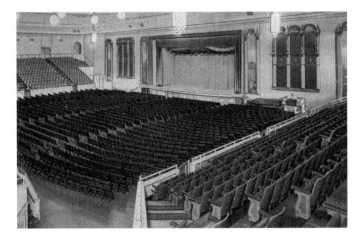

Interior of Convention Hall, 1930s. *Courtesy Asbury Park Library.*

constituents. He made mysterious trips around the country and abroad, including a December 1933 voyage to London and back, but the exact purpose of his travels, other than that they were connected with UP&L, remains unclear to this day. On the 1930 census, Hetrick listed his sole employer as the City of Asbury Park. In addition to a legal address on the city's Fifth Avenue in a home valued at $25,000, far more than those of his neighbors, where he lived with his wife, Ida, and widowed sister in law, Caroline Hagerman, the mayor maintained an apartment in the Mayfair Hotel in New York and another in the Shoreham Hotel in Washington, D.C., as well as a resort home in upstate New York. Hetrick maintained an office in the Eastern Power & Light (an affiliate of UP&L) Company's eleven-story Asbury Park Electric Building, the city's "first skyscraper," which he had dedicated with much hoopla in 1927 and where "he was ostensibly operating a real estate business," according to local papers. The mayor's early promise to run the city like a "successful corporate business" was resonating with a deep irony he no doubt ignored.[94]

Still, in 1931, as the national economy slipped deeper into economic disaster, Hetrick and his fellow commissioners continued to project a rosy future for Asbury Park in a brochure apparently aimed at convincing the public to continue their electoral dynasty. The book, published by a Hetrick front organization styled as the "Progressive Citizens' League of Asbury Park," was intended to trumpet the "growth, progress and achievement

The new Asbury Park High School, which opened in 1927 as part of Hetrick's expansion of public construction and still stands on Sunset Avenue. *Courtesy Asbury Park Library.*

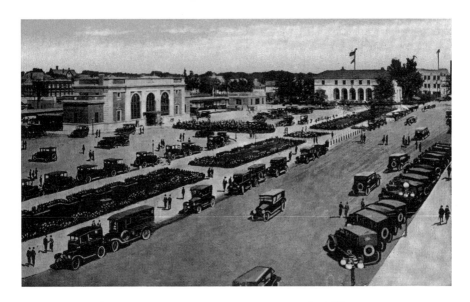

The Asbury Park railroad station in the 1930s. *Courtesy Asbury Park Library.*

during the past fifteen years of America's premier all-year resort and residential city." According to the breathless prose of the work, "in the past fifteen years Asbury Park has gone modern." Assuring the reader that "statistics are confusing," the writer went on to produce reams of them, from both public and private sectors, along with photographs of every building, from residential bungalow to Convention Hall, erected in the city since 1915, touting the value of each. Everything was up to date in Asbury city, for sure, the mayor assured his constituents. But they had indeed gone about as far as they could go.[95]

Beneath the surface, things were not so rosy. In addition to his mysterious dealings on behalf of UP&L, Hetrick and his administration were involved in increasingly shady local affairs. No type of sleazy deal seemed too small. Imported voters allegedly participated in city elections for "four bits and a shot of rum." Mobsters and bootleggers acquired permits to carry concealed handguns from the Asbury Park Police Department based on phony local hotel addresses. The beachfront that Hetrick rebuilt at city expense not only failed to turn a profit but suffered increasingly deep deficits as well. Jonas Tumen, a partner in an Asbury Park law firm with his brother, a city judge, was appointed Monmouth County prosecutor in 1930. According to a New Jersey Assembly committee investigating the Tumens, who had offices in the Electric Building, they were apparently running a protection racket on speakeasies and gambling establishments and were in cahoots with a variety

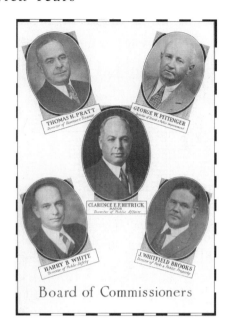

Mayor Clarence Hetrick (center) and his fellow commissioners in 1931. *Courtesy Asbury Park Historical Society.*

of gangsters, as well as taking advantage of rigged bidding on city property foreclosures, in a disastrous economic environment where 46 percent of the town's property owners could not pay their property taxes.[96]

By 1933, outraged citizens formed a reform ticket to unseat Hetrick and banish his accomplices, most notably the Tumens, and change the commission form of government to a mayor and council structure with a professional city manager. In a rough campaign that produced at least one shooting of an anti-Hetrick voter, the reformers won. Not a man to accept his dethronement quietly, the ex-mayor immediately began a multipronged counterattack that ended up with the new city manager rapidly leaving town and several reform councilmen being indicted over alleged political deals for votes.[97]

DISASTER COMES ASHORE

In the middle of its political travails, the beleaguered little city by the sea would soon get an unforeseen, if temporary, economic boost from disaster. The luxury liner *Morro Castle*, along with its sister ship the *Oriente*, was specifically built in 1930 to make rapid round trips between New York and Havana, Cuba. The ship, which had a capacity of more than seven hundred passengers and crew, served liquor as soon as it was out

of United States waters and became a floating party boat during the last days of Prohibition, an attribute that added to its popularity. Those who still had money to travel in the depths of the Depression no doubt also appreciated the psychological lift provided by the sun, sand, rum and lively music in Cuba.

Captain Robert Wilmott piloted the *Morro Castle* out of Havana harbor bound back for New York on September 5, 1934. The liner entered New Jersey waters two days later, where it ran into a classic northeaster storm featuring wind, rain and high seas. Although seemingly unperturbed by the weather, Wilmott declared that he felt ill, had dinner in his room and went to bed. The captain died in his sleep of an apparent heart attack, leaving Chief Officer William Warms in command. Warms continued on course for New York, but in the early morning hours of September 8, a mysterious fire broke out aboard the *Morro Castle*, and within a short period of time, the ship was completely ablaze. The liner's highly flammable wood finishes and tropical ventilation system, exacerbated by high winds and Warms's increase in speed in response to the fire, fanned the flames, which burned through the *Morro Castle*'s controls, leaving it helpless. As the ship drifted toward the New Jersey shore, Warms halted it by dropping anchor two miles off Sea Girt, where he waited for help amid growing onboard chaos as passengers and crew fought for lifeboats or simply jumped overboard into the roiling sea in life vests. Help would arrive, but too late for many. George Rogers, the radio operator, sent out repeated SOS pleas that brought rescue vessels to the area and appeared the hero of the hour. Some researchers would later claim that Rogers was actually the arsonist who started the blaze, although definitive evidence would never surface.[98]

The pleas drew responses all along the coast, with other ships at sea rushing to the area and fishing boats and Coast Guard vessels plying out from shore. Residents of seaside towns from Point Pleasant to Belmar rushed to the beach to pull survivors and victims out of the surf. New Jersey governor A. Harry Moore, winding up his final summer season in the "governor's cottage" at Sea Girt, dispatched the National Guard's African American First Separate Battalion, in camp for annual training, to the beach to help. Moore himself courageously flew out in the observer seat of a National Guard plane to mark floating survivors for rescue boats. In the end, 135 of the 549 passengers and crew aboard the *Morro Castle* died. When all had evacuated and the fire died down, the Coast Guard cutter *Tampa*, based in Staten Island, began to tow the still-smoking hulk toward New York. Off Asbury Park, the *Tampa*, struggling against the weight of the dead ship and the tide, began to lose control. The towline snapped.[99]

Radio station WCAP, Asbury Park's chamber of commerce radio station broadcasting from Convention Hall, reported the developing tragedy from the beginning. Station manager Thomas F. Burley Jr. stayed on duty, interrupting regularly scheduled programming to advise the public on the latest *Morro Castle* news. Toward evening, Burley uttered a cryptic bulletin, "The *Morro Castle* is adrift and heading for the shore." Even so, he was shocked to look out the window about 7:30 p.m. and see the ghostly liner bearing down toward the beach directly in front of him. As Burley began a station break, he gasped, "My God! The *Morro Castle* had arrived in Asbury Park."[100]

Although it must have seemed to Burley that it was going to end up in his lap, the ship drifted sideways into the surf and crunched to a stop about a hundred yards offshore. It glowed like a hot coal, with sudden brief bursts of flame, throughout the night, as locals came down to watch the fireworks. R.W. Hodge, commander of the local Coast Guard district, watched as well. In the morning, firemen ran a line out to the ship from Convention Hall and Hodge was shuffled aboard via a breeches buoy. He was appalled by the scene that greeted him. What appeared to be a body burned beyond recognition lay amidst a scattering of shoes and other debris, some of it melted into the deck. Smoke still spiraled up from the wreck and the heat was so intense that Hodge blistered his hand and the soles of his shoes melted as he poked about looking for evidence of what had happened.[101]

It didn't take local flimflam men long to set up some access and start charging admission to the wreck for reporters and the curious. Journalists reported that they paid five dollars to get aboard, another five dollars to rent

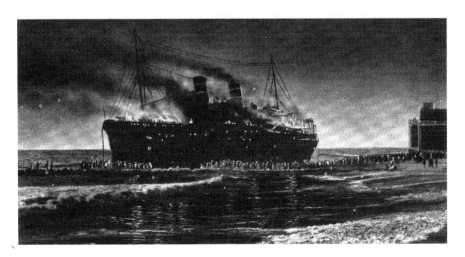

The *Morro Castle* on fire at night off Convention Hall. *Courtesy Asbury Park Library.*

A close-up view of the wreck of the *Morro Castle*. *Courtesy Asbury Park Library.*

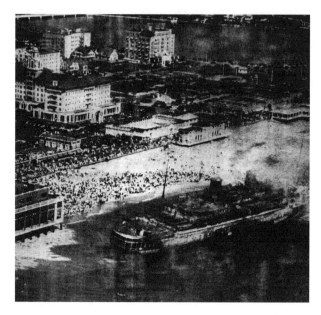

The *Morro Castle* and Asbury Park as seen from the air, September 1934. *Courtesy National Guard Militia Museum of New Jersey/Sea Girt.*

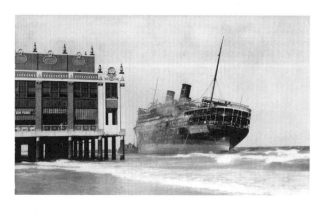

The *Morro Castle* where it came to rest off Convention Hall. *Courtesy Asbury Park Library.*

a gas mask to ward off noxious fumes and yet another dollar for the use of a flashlight. City officials denied any connection with the grifters running this particular scam (who suddenly disappeared) but quickly instituted their own program to charge disaster visitor fees to the beach. A nineteenth-century Asbury Park newspaperman had once posited that the town needed "a first class shipwreck" to boost tourism. Now it had it. Signs directing visitors to the still-smoldering hulk were erected almost instantly on nearby roads, and as many as 100,000 tragedy tourists flocked to the beach over the next few days. The merry-go-round and other amusements were going strong as saltwater taffy and popcorn sales boomed. *Morro Castle* postcards appeared for sale on the boardwalk almost immediately.[102]

There were numerous suspicions as to what had happened. On Monday, the *New York Daily News*, promising readers "six pages of ship fire pictures," headlined "Probe Ship Blast as 'Murder.'" The publicity of criminal possibility actually increased tourism to Asbury, and the number of visitors rapidly approached 250,000. With money pouring into the Depression-stricken resort, the reform city government began to think about acquiring the *Morro Castle* as a permanent tourist attraction but backed off when city councilman Dr. Max Silverstein called the idea "shocking" and "revolting." The novelty wore off after a while, especially when the *Morro Castle*'s below-deck cargo of animal hides began to rot and the stench wafted over the beach. In the end, the merchants and politicians of Asbury Park were not sorry to see the rusty, malodorous wreck finally go when it was towed off for scrap on March 14, 1935.[103]

HETRICK REDUX

As the *Morro Castle* hulk corroded just offshore, the city's handling of the whole affair cast doubt on the effectiveness of its new government. A subsequent default on bondholder debt and the revelation that Asbury Park was bankrupt, coupled with threats of a state takeover of the city's fiscal affairs, raised the public's disenchantment level with the reformers (even though Mayor Hetrick was responsible for the bankruptcy) and set the stage for a Hetrick comeback under the umbrella of a front group called the "Asbury Park Civic League" (a riff on Hetrick's previous organization, the "Progressive Citizen's League of Asbury Park"). The sudden death of Mayor Sherman Dennis and squabbles among the reformers provided an assist to the former mayor's return to power through a recall election, which occurred in April 1935. Once back, although he promised he would solve "the acute problems which

involve the city," Hetrick wasted no time in restoring the old status quo. Although the UP&L trust was broken up by the federal government, Hetrick had other tried-and-true financial resources. Bookies reopened for business, and political allies regained valuable boardwalk concessions for special reduced rates, including a bathhouse season concession rental slashed from $85,000 to $40,000. There was renewed access to good buys on properties foreclosed for taxes for Hetrick friends like the Tumens, and the revenue from parking meters installed along the boardwalk mysteriously disappeared. Times remained tough for the little guy, however, and a number of the larger houses in town began to be subdivided into rental units by their owners in efforts to earn enough to meet the city property tax bill. Federally funded public housing was erected but only on the West Side. You could still hustle a few bucks here and there around Asbury during the Depression, though, and teenager Joe Travers started a small business trapping muskrats and foxes on the outskirts of town for the New York fur market.[104]

Within months of his return, Mayor Hetrick and his councilmen narrowly escaped jail on a contempt of court charge resulting from a lawsuit filed by unpaid city bondholders. By October, he was in Washington, testifying before the Securities and Exchange Commission. After establishing that Hetrick "had long been retained in a personal and confidential capacity by H.L. Clark," the commission strangely left that potential conflict of interest and took on the subject of the city's financial collapse and bond default under "municipal debt occasioned largely by waterfront developments that later were the subject of glaring iniquities in renting." Denying any wrongdoing, the mayor promised corrective action and returned to New Jersey and business as usual. By the spring of 1941, a new reform ticket, the United Citizens League, rose to challenge the Hetrick machine once more. As always, Hetrick promised that immense progress, with trickledown prosperity for all, was just around the corner and reminded the public that his administration had planted 250,000 tulips in town. He hired George Zuckerman, a PR man in the Ayres mold, to promote the city and its events. Zuckerman pulled a "Mrs. America" pageant out of his hat in an effort to compete with Miss America's Atlantic City coronation. In the end, tulips and Mrs. America were of no avail, and Hetrick lost the mayoralty but remained a city councilman. Then, on October 13, he died of diabetes and thrombosis.[105]

Clarence Hetrick was an old-fashioned political boss, in an era of notable New Jersey bosses whose careers roughly paralleled one another. The most famous was Jersey City's Democratic mayor Frank Hague. Born in 1876 in the Irish "Horseshoe" ghetto in Jersey City, Hague was elected mayor in 1917 and held office through 1947. He enriched himself by providing protection

Fishing on the Asbury Park pier on the eve of World War II. The pier was destroyed in the great storm of September 1944 and never rebuilt. *Courtesy Asbury Park Library.*

Sunset Lake in Mayor Hetrick's Asbury Park, 1937. *Courtesy Harry Ziegler.*

for gamblers, charging civil service employees an annual percentage of their pay as compensation for employing them and taking a cut of construction and other government contracts, among other things. For all his faults, and there were many, Hague gave back to his community, building Jersey City Medical Center, where city residents received excellent medical care at little or no cost, and Roosevelt Stadium and other public projects, as well as creating an excellent school system. Hague's district leaders—who organized a block vote that resonated at both state and national levels and helped make governors and presidents—assisted people in need in exchange for their votes in an era before government social services. Finally chased out of office by the new reformist state constitution of 1947, Hague died in retirement in New York City in 1956. Although the Asbury Park mayor barraged his constituents with statistical proof of their collective prosperity and provided a steadily diminishing trail of crumbs, Hetrick's organization profited only his cronies, not the citizens who lost their homes through foreclosure during the Depression, nor the African Americans who had loyally supported him only to continue to be confined to still-segregated beaches and schools. True, by 1931 there was an African American on the city police force and several others in city employment, and black citizens and vacationers no longer had to wait until late afternoon or evening to visit the beach, but their beach visits were confined to a conveniently out-of-sight area south of the Casino on the Ocean Grove border.[106]

Enoch L. "Nucky" Johnson, the Republican boss of Atlantic City, was a contemporary of Hetrick's whose career more closely matched the Asbury mayor's than Hague's. Johnson purloined public money and, like Hetrick, gave little in return. Son of Atlantic County sheriff Smith Johnson, he was born in 1883 and gained political prominence after guiding the successful senatorial campaign of Walter E. Edge in 1916. Far more flamboyant than his Asbury Park or Jersey City counterparts, Johnson rose to become Atlantic County Republican Party chairman and county treasurer from 1911 through 1941. During his reign, Atlantic City was a playground for organized crime, including speakeasies, gambling dens and brothels, all of which paid fees to Nucky to operate freely. Expanding his base, Johnson became a powerful statewide political figure and lived a flashy lifestyle, highlighted by regular appearances in Atlantic City and New York nightclubs with showgirls on his arm, all paid for by an illegal income estimated at $500,000 a year. Johnson was eventually indicted for income tax evasion in 1939, was convicted and served four years in federal prison. He was paroled four years later and died in Atlantic City in 1955.[107]

WAR AND PEACE

By the end of 1941, the Asbury Park of the recent past was as dead as "Toad" Hetrick. The local paper proudly noted that the marchers in the Fourth of July parade that year included Holy Name Society members and Jewish War Veterans. Members of the Ku Klux Klan were nowhere to be seen. Even in Long Branch, home to the tri-state Konklave of 1924, Klansmen were notable by their absence, although one 1940 account noted that there were rumors the Klan was "said still to hold secret meetings in the woods back of the town, but there has been no public evidence of such activity."[108]

Any residual Klan feelings in New Jersey, even in Monmouth County, remaining after the organization began to fall apart in the mid-1920s were largely swept away by the real problems of the Great Depression. As the 1930s came to a close, the rise of aggressive totalitarian regimes in Europe and Asia, and the threat and then actuality of war, was on everyone's mind. Like much of America, Asbury Park began to assume a war footing even before the United States was actively involved. On September 16, 1940, President Franklin D. Roosevelt signed a law introducing peacetime military conscription for the first time in American history. That day, National Guard troops across the country, including the men of Headquarters Detachment and Company G of the 114th Infantry Regiment—lineal descendant of the old Companies A and H of the Third, whose home station was the Asbury Park Armory—began to mobilize for an obligatory one-year term of service for training. That one year was to turn into almost five before the guardsmen returned. In their place, New Jersey raised a "State Guard" militia. The Asbury Park Armory became the home of Company B of the State Guard's Eighth Battalion. In December 1941, within a week of the Pearl Harbor attack, Company B left the city to assume temporary guard duty on the Route 9 Victory Bridge across the Raritan River.[109]

By the spring of 1942, as its men began to leave for military service, the war came home dramatically to the New Jersey Shore. In June, a seven-mile stretch of beach south of Asbury Park, from Belmar to Manasquan, was covered with "oil and tar residue" and debris from sunken ships as the Nazis launched Operation Drumbeat, an all-out attack on American shipping in which German submarines came so close to the coast that the crewmen listened to local radio stations.[110]

In response, the army's Second Corps military command, which included New Jersey, advised the state's governor Charles Edison that it "desired all lights along the New Jersey seacoast be dimmed or eliminated as the present lights silhouetted a ship at sea making it an easy target for submarines lurking

State Guardsmen from Asbury Park on duty, guarding the Victory Bridge over the Raritan River in December 1941. *Courtesy New Jersey State Archives.*

beyond the sea lanes where ships travel." Leonard Dreyfuss, director of the state's Defense Council, said that he would contact the municipal officials of the shore towns, who had already expressed a desire to cooperate. Although local citizens in Cape May were annoyed that the Cape May Naval Base was not subjected to the same dim-out regulations that they were, by March 24 the navy expressed itself as "quite satisfied" with the dim-out between Atlantic Highlands and Sea Girt, although reports of results farther south were mixed.[111]

A bit of conventional wisdom accepted by many historians is that in the spring of 1942 merchants in coastal communities like Asbury Park deliberately violated government dim-out directions in order to continue to attract tourists, an act that led to the sinking of American ships. One historian has asserted that "ships and lives were held hostage to tourist dollars." This view apparently has its origins in the work of highly respected Harvard scholar Samuel Eliot Morison, who wrote the navy's official history of the war and called this alleged defiance "most reprehensible." The problem with Morison's account is that, at least in the case of New Jersey, it was completely untrue, as a reading of the state's "Governor's War Cabinet Minutes" readily reveals.[112]

On April 9, Director Dreyfuss reported to Governor Edison that he had visited Asbury Park at night and that "the town was in almost total darkness." Far from being concerned that merchants were defying the regulations, Dreyfuss felt that "it was not necessary that the dim out be so complete" and

suggested that the governor confer with military authorities on the matter. Two weeks later, the navy reported that although some Cape May lights could be seen thirty miles at sea, they were "not objectionable" and that "generally all of the [coastal] dim out was acceptable." By May, state officials thought the dim-out along the whole coast "most effective," although some Atlantic City lights were still too visible. An assessment two weeks later, however, pronounced New Jersey's efforts as "about as perfect as could be expected."[113]

In late May, federal regulations on coastal lighting were tightened to include traffic lights and all exterior advertising, as well as automobile headlights. Drivers in coastal towns were only allowed to use their parking lights, which caused a rise in automobile accidents almost immediately. An end-of-the-year assessment concluded that dim-out programs increased vehicular accident rates by 100 percent. Although some navy officers were not completely satisfied that the new regulations were being effectively enforced, a team of state officials and an army general conducted a thorough inspection from the sea on June 1 and concluded that "New Jersey was effectively dimmed out" with the exception of the U.S. Navy installation at Cape May. Photos taken from the ocean afterward revealed that "navigation lights definitely made a glare or glow, whereas normal lighting in cities such as Asbury Park and Long Branch showed up black in the photographs."[114]

Navy complaints continued, and at the end of July the Governor's War Cabinet received a letter and a series of time-lapse photos allegedly revealing incomplete dim-out compliance in some shore communities, including automobile headlights in Mantoloking pointing seaward. Dreyfuss thought the evidence invalid, but Edison agreed to look into it. A subsequent state police investigation revealed that the photographs were overexposed and that dim-out regulations were reasonably well obeyed and enforced and that the dim-out in Asbury Park in particular was "quite effective." There is absolutely no evidence to sustain Morison's allegations that New Jersey Shore merchants deliberately disobeyed dim-out regulations to bolster their tourist trade during the deadly summer of 1942.[115]

As the conflict continued, Asbury Park residents continued to do their duty. Not only did they serve in the military in all branches of service and all theatres of the war, but also as civilian members of fraternal and other organizations like the Sons of Italy, who contributed to the cause by holding scrap drives. The war also led to a surge in the city's already-significant black population, as the segregated West Side was one of the few places in Monmouth County that welcomed African Americans migrating north for war jobs in New Jersey's industry. By war's end, with black workers shoehorned into limited, largely substandard and increasingly decrepit

The Asbury Park Sons of Italy Scrap Drive, held during World War II. Michael Travers is the fourth man from the right, standing. *Courtesy Travers family.*

rental housing in the Springwood Avenue area, African Americans, always a significant presence in Asbury Park, made up a quarter of the city's population.[116]

As with many coastal resort cities, Asbury Park's major hotels became barracks during World War II. In September 1942, the U.S. Army Signal Corps took over the Kingsley-Arms at Kingsley Street and Deal Lake Drive, while the navy leased the Monterey and the Berkeley-Carteret and turned them into an "in transit" quarters for British and Commonwealth sailors between ship assignments, many of whom were assigned to vessels being transferred to the Royal Navy under terms of the Lend-Lease Act. A USO center was established on Grand Avenue and welcomed American and Allied soldiers and sailors alike, and inter-service rivalries were played out in rowing contests on Sunset Lake. In February 1943, the British sailors left town, turning over their hotel accommodations to the U.S. Navy Pre-Midshipman School, mustering over three thousand cadets awaiting assignment to officer candidate schools.[117]

Perhaps the greatest problem Asbury Park faced during the World War II years was the great storm of September 1944. Starting as a light rain on the evening of September 14, it quickly worsened, dropping a total of four and a half inches of precipitation in five hours. Winds rose to eighty-five miles per hour, and the surf cascaded as far inland as Kingsley Street,

The Berkeley Carteret and Monterey Hotels in the 1930s. During World War II, both were used by the British and U.S. navies. *Courtesy Asbury Park Library.*

The storm-wrecked boardwalk in September 1944. *Courtesy Travers family.*

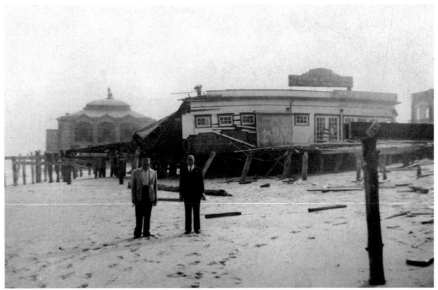

The storm-wrecked boardwalk in September 1944. Michael Travers is on the right. Convention Hall is in the background. *Courtesy Travers family.*

severely damaging the Casino and Convention Hall and shattering much of the boardwalk. The municipal fishing pier, dating to the days of James A. Bradley, was totally destroyed and never rebuilt. In the wake of the storm, sailors from the Pre-Midshipman School provided security while merchants and city officials surveyed the property damage, which came to more than $250,000. The storm created a surge of 6.3 feet, the largest ever recorded along the Jersey Shore.[118]

By the end of World War II, the last of Mayor Hetrick's cronies had died, and Democrats held the edge in the city council. Still, in 1945, they elected as mayor a Republican, George Smock II, a local lumberyard owner and adherent of the original Hetrick vision of Asbury Park as a commercial and tourist hub. Some residents saw continued cronyism in Smock's election, maintaining that he was the personal pick of local Democratic Party leader and attorney Joseph Mattice, one of the early 1930s reformers. After the election, Smock appointed Mattice a municipal judge, all the while claiming that there had been no deal to do so. And so Asbury greeted yet another new world with a whiff of its old politics. Wherever he was, the ghost of Clarence Hetrick must have cracked a smile. But dramatic and unforeseen changes were in store. The merchants' hegemony, dating from 1903, would begin to crack.[119]

THE FALL AND THE RISE

THE MERCHANT KINGDOM

With depression and war behind it, Asbury Park seemed poised on the verge of a new wave of prosperity in 1945. Although the city's merchant kingdom slowly began to be undermined, its final collapse would be a drawn-out affair and went unrecognized for decades. It could be said with certainty, however, that the day the registers rang for the last time at Steinbach's department store on Cookman Avenue thirty-four years later sounded the undeniable death rattle of Asbury Park's downtown and, for a while, the city itself. When the massive five-story department store bolted its doors with finality on a grim Saturday in July 1979, the closing marked the departure of a more than one-hundred-year-old business that epitomized the allure and excitement of shopping in Asbury Park.

The reasons for closing seemed clear. Asbury had never recovered from the upheaval of the city's 1970 riots. Although the whole explanation for the city's deterioration, as well as that of other urban areas across the country, was more complex, racially rooted civil disturbances were a significant contributing factor in revealing the Potemkin village–like façade of many postwar American cities and provided a convenient point of departure. By the late 1970s, Press Plaza—the convergence of several streets in front of the *Asbury Park Press* main office—was a shabby remnant of its illustrious past. Consumers were flocking to the well-lit, secure attractions of Monmouth Mall in Eatontown and Seaview Square Mall in Ocean Township, and Steinbach's, in comparison, was a quaint and somewhat pathetic souvenir of another era.

Steinbach's department store in the 1950s.

And yet what an era it had been. For all its problems, Asbury Park, fulfilling Clarence Hetrick's grandiose dream, had been the shopping hub for Monmouth and Ocean Counties for decades, offering a glittering array of stores and services that could not be found in such abundance anywhere else in the region. Towering over all these businesses was the stately Steinbach building, its clock tower a beacon that drew consumers into the heart of downtown.

Like many other businesses of the age, the Steinbach store came to Asbury Park when the city resembled a frontier town, somewhat primitive compared to the glittering elegance of Long Branch. But founder John Steinbach was convinced that the emerging resort offered enormous opportunity when he set up shop there in 1874. During the late 1870s, when the store was at the corner of Lake Avenue and Main Street, it was a simple enterprise with goods heaped on a counter, overseen by a single clerk in a gaslit room. But as Asbury grew in size and stature, so did Steinbach's. In the 1890s, John Steinbach embarked on a massive construction project that resulted in the new store on Cookman Avenue. With its eye-catching plate glass display windows, beige brick exterior and sumptuous interior of mahogany showcases and terra-cotta molding, the magnificent structure was designed to represent the rising social status of Asbury Park. Originally built as a four-story structure, a fifth floor was added several years later to make the building even more imposing.[120]

The Fall and the Rise

In 1906, the *Asbury Journal* singled out the Steinbach establishment as an impressive example of architectural genius, praising its designers, Robert Cleverdon and Joseph Putzel. The article provided a detailed tour of the store, starting with descriptions of the impressive counters and cases on the first floor and moving to the second level, which was devoted to men's and women's clothing. The third floor featured crockery and a separate department devoted to hardware, "where one can buy any article entering into the construction of a house." The next two floors, occupying a space of nearly thirty thousand square feet, featured "furniture of every description modeled after the colonial, mission and Louis XVI styles."[121]

The writer was especially lavish in his praise of the fifth floor, with its richly stained wood trim and the spaces between that were painted Chinese white. One of the principal features of the room was a large imitation fireplace on the south wall, with a finish of weathered oak. "The Steinbach Company has set a pace for others to follow, and while it would be impossible for all to build a 'Mammoth,' yet the generous treatment of their building in all its entirety should be an example for others, however small their undertaking," the reporter gushed.[122]

To establish and maintain such a successful enterprise required stamina and vision, and John Steinbach represented the type of feisty, single-minded entrepreneur who molded Asbury Park into a formidable business hub. He moved to the United States from Austria via Halifax, Canada, and opened his first store in Long Branch. Seeing the potential for expansion, he summoned his brothers, Henry and Jacob, from Europe, and began to consolidate his department store mini-empire. John Steinbach believed in personalized service and would personally greet each of his customers, making sure that no one was waiting for service. His wife, Eugenia, had two children, Walter and Arthur, before her death shortly after Walter's birth. The grief-stricken Steinbach never remarried.[123]

Instead, the elder Steinbach threw himself into the business, leaving the care of his sons to the family "help," with the housekeeper "Noanie" in charge. If Asbury was a merchant kingdom by the sea, Walter and Arthur were surely its crown princes. As his sons grew into manhood, Walter became an intellectual philanthropist who thought nothing of dispensing his time and money to help the needy, while Arthur evolved into a consummate, profit-oriented businessman, rigid and precise in his ways. While Walter hobnobbed with members of the "Lost Generation" in the Paris of the 1920s, Arthur focused on expanding his family's holdings and became obsessed with the building and decorating of the Berkeley-Carteret Hotel, in which he had a significant financial stake.[124]

"It was told that he once fired a bellboy for having dirty shoes," recalled Nancy Gibson Harvey, Walter Steinbach's grandniece, describing Arthur Steinbach's attention to detail when it came to the Berkeley-Carteret. "He also gave careful thought to how every room should be made up. He would spell it all out to the maids: 'Make the bed first. Then, even if there is more work to be done, the guest can, at least, put his suitcase down in his own room. Do the rest after that.'"[125]

Perhaps most significantly, the Steinbach family represented the type of Asbury Park businessmen who, while concerned with profit, also became civic-minded advocates for the community. When the city was crippled by the famed three-day blizzard of 1888, Steinbach employees undertook the massive cleanup of Main Street. The company was also instrumental in coordinating the first baby parade in 1890.[126]

Even more importantly, the Steinbachs set an example by refusing to yield to the racial intolerance of the 1920s' Ku Klux Klan. When Klansmen, as self-styled guardians of white Protestant America, began to target Catholics, Jews and blacks, the German-Jewish Steinbachs opted to take a public stand against the bigotry and made it a point to open their doors to African Americans and other ethnic minorities. "They made friendliness and helpfulness to these groups a store policy," recalled Harvey.[127]

Arthur, who died in 1957, and Walter, who passed away in 1972, were the last of the Steinbach family who ran the dynasty for more than seventy years. Reflecting on their legacy on the eve of the store's demise in 1979, Harvey said, "The legacy of the Steinbachs is the spirit of youth and hope—that there's nothing impossible for those who believe. The Steinbachs took risks. They were willing to make commitments."[128]

And yet there was something inescapably sad in those words, for the spirit and vision of the Steinbach family was fading as the shelves and counters of their landmark store were being cleared forever. It was hard to imagine, on that poignant last day of business in July 1979, that Steinbach's had once reigned as the premiere department store of the region, presiding over a bustling, energetic downtown.

Yet for decades, the Steinbachs and other Asbury businessmen presided over a formidable merchandizing empire that proved a mecca for thousands of shoppers. What began as a straggling collection of frame buildings in the 1870s had already become a thriving downtown in 1890, concentrated at the convergence of Cookman, Mattison and Bangs Avenues, the site of the future Press Plaza. A western footbridge, connecting Ocean Grove to Asbury's Emory Street, led shoppers to a range of businesses that sold everything from birds to cigars.[129]

The Fall and the Rise

One significant aspect of the downtown's development was the rise in stature of immigrant entrepreneurs, who often initially set up shop on the less-fashionable West Side of the railroad tracks and then worked their way into influential positions with prestigious establishments on the sought-after East Side of town. Most of these merchants were Jewish immigrants. Most of the early Jewish residents, beginning with a group of about thirty families in 1897, operated as small tradesmen along Springwood Avenue, but by 1899 there were several Jewish businesses east of the tracks, including Goldstein's clothing store and Schlossbach's men's furnishings. By the 1920s, the Jewish community was a thriving and dominant presence in the city's Cookman Avenue business district.[130]

Initially worshipping in a room over a butcher shop on Springwood Avenue, Asbury Park's Jews established a permanent synagogue at Cookman Avenue and Langford Street in 1905. As the Jewish population grew, other organizations were formed to meet the residents' needs, including a Hebrew free loan association and the Hebrew Ladies Aid Society. By the 1930s, Jewish citizens were well-established and influential residents of the city and founded a community center at Asbury Avenue and Comstock Street that served as a meeting place for the Jewish War Veterans and numerous other groups.[131]

As it became evident that the growing population in the shore area would support a substantial business district, Asbury's buildings became more impressive. Thus, by the 1920s the town's downtown structures included the five-story brick headquarters of the *Asbury Park Press*, the massive Sea Coast Trust Company bank on Cookman Avenue and the twelve-story Eastern New Jersey Power Company "skyscraper" at Bangs Avenue and Emory Street. On the main floor of this imposing edifice, showrooms displaying new electric appliances were intermingled with business offices, while the upper floors were used exclusively for office space, including one in which Mayor Hetrick performed UP&L private sector duties that were never exactly clear.[132]

Perhaps the most breathtaking evolution of Asbury's downtown coincided with the rise of motion pictures, which had evolved into a thriving industry by the 1920s. Fans thrilled to the latest black-and-white exploits of their favorite stars, and the increasing opulence of movies was matched by the magnificent "palaces" that showcased them. As an entertainment center for the region, Asbury led the way in the size and number of movie theatres, and 1927 was a banner year for the city's movie scene when the Mayfair, a million-dollar Spanish-Moorish palace on Lake Avenue, opened its doors.

"Elegance of Structure Proves Real Revelation" trumpeted the headline in the August 6, 1927 edition of the *Asbury Park Press*, in a lengthy page-one story that detailed the premiere of impresario Walter Reade's newest and finest playhouse. A fashionable audience of some 1,500 guests in evening dress attended the opening. They were addressed by Mayor Hetrick, who lavished praise on the majestic edifice. "Mr. Reade has done a great deal for recreation, and this theater stands as a tribute to the man who built it," he said. "Recreation comes second to the church and school."[133]

During the evening, the star-struck first nighters wandered around the new building, marveling at its enchanting Spanish-Moorish architecture. After passing through giant grill doors at the entrance, visitors entered the spacious lobby. In the center was a large Spanish well, surrounded by floral pieces, huge vases and pieces of Spanish art. Once inside the auditorium, guests marveled at the seats of Moroccan leather with hand-woven tapestry backs. There were 1,260 seats in the orchestra section, and a reporter noted that "there is hardly a seat in the house from which the spectator cannot see the screen as good as those seated in the very center of the house near the front." To provide the "mood music" so integral to the silent movie experience, the Mayfair boasted a Möller organ featuring six thousand possible controls, with a separate keyboard connected to tower chimes.[134]

Sitting in the orchestra, one had the sensation of being outdoors, thanks to hidden lights that created a scene of clouds and stars on the expansive ceiling. Five beautiful drop curtains were positioned between the screen and footlights, one of light red and studded with rhinestones, and the others of varying colors. Patrons relaxed in comfort, thanks to a modern ventilation and cooling system. Basking in the compliments of the awe-struck crowd, Reade vowed to provide the very best in theatre entertainment. "Their words of praise encourage me and I am more than ever determined to give the people of this section the best possible in the Mayfair," he said.[135]

In 1931, Mayor Hetrick and his city promoters published their overwhelmingly optimistic glossy book describing the city's progress and achievements from 1916 to 1931 in an apparent effort to justify the massive bond debt the city had accrued in the face of a deepening economic depression. Along with the numerous photos of shops, public buildings and homes throughout the city, there were glowing essays describing its services and quality of life. "In the past fifteen years, Asbury Park has gone modern!" the book exclaimed. "Millions of dollars have been invested in improved streets, parks and public properties."[136]

Characterizing Asbury as the "residential city ideal," the book clearly defined it as the shopping hub of the region, noting its "outstanding"

department stores that "annually bring thousands of visitors from all parts of New Jersey." The publication touted city stores as "the finest specialty shops in the country…There is not a single phase of merchandising which is not represented." Certainly, a sumptuous two-page advertisement in the December 1937 issue of *Monmouth Pictorial*, an upscale glossy magazine dedicated to the comings and goings of high society in Monmouth County, testified to that. The ad highlighted the handsome two-story brick complex of shops at 527 Bangs Avenue, a range of establishments suggesting the wide variety of services to be found in Asbury. They included A.J. Poland's, "specialist for forty years in fine jewelry, precious stones and sterling silverware"; Rogers and Conover's exclusive millinery shop; Watson Hair Studio, which offered "scalp treatments for gentlemen," and the Rendezvous Gift Shop, purveying a range of kitsch novelties from cocktail sets to snowstorm paperweights to those who still had a job by that date.[137]

Despite the onset of the Depression, there is no doubt that Asbury Park's numerous amenities made it one of the most sophisticated and desirable places to shop along the Jersey Shore, and frequent bus service to and from outlying towns made it convenient as well. To publicize all these attractions, an aggressive chamber of commerce was committed to "selling Asbury to the world as a foremost resort, where health and happiness abound."

Not everyone was in severe financial straits in Depression-era Asbury Park. Here a shopper confers with Bangs Avenue jeweler A.I. Poland on a purchase. *Courtesy Harry Ziegler.*

A section of the Bangs Avenue shopping strip in 1937. *Courtesy Harry Ziegler.*

The 1931 Hetrick publication touted a pre-Depression increase in winter convention crowds as an example of Asbury's year-round appeal, citing the farsightedness of administrators (now running for reelection) who proceeded with beachfront improvements like Convention Hall and the Casino in the 1920s. The Hetrick coalition maintained that Asbury Park would have felt the deepening economic downturn to "a serious extent" without the boardwalk renovations. Within a few years of the publication of those words, however, the city was in receivership, its fiscal future in the hands of the State of New Jersey.[138]

POSTWAR COMEBACK

With the economic upturn precipitated by World War II, and the postwar boom of the late 1940s that lasted into the 1950s, Mayor Smock's Asbury Park seemed to have shed the dark days of Depression. Press Plaza, the heart of downtown, provided an energizing pastiche of workers and shoppers, hustling and bustling to and from department stores, offices and banks. Reporters and editors hurried in and out of the offices of the *Asbury Park Press*, which had become the premier newspaper of the region, on their way to file stories and edit pages for the next day's edition. Salesgirls hawked perfume and lipstick from behind the glossy counters at Steinbach's, while

office workers grabbed a quick cup of coffee and a sandwich at one of the numerous lunch counters and restaurants. Busses, which had long since replaced the trolleys of the 1920s, crisscrossed the downtown, dropping off housewives from in and out of town (many yet without their own cars), eager for a day of shopping and errands. The names of downtown stores rolled easily off the tip of the tongue, a catalog of mid-twentieth-century American retail merchandising: Lerner's, Newberry's, McCrory's, Woolworth's.

The West Side's Springwood Avenue was a dynamic business center as well at mid-century. The neighborhood had long been home to the city's African American population, deemed essential for the housekeeping, cooking and bellhop jobs on the East Side hotels, but segregated in a de facto (if not de jure) manner. In a detailed reminiscence later published in the *Asbury Park Press*, West Side resident Renee Freeman recalled the joys of shopping on "the avenue." She recalled Mr. Goode's hair care store, stocked with pomades, and Mr. Rabin's candy store with its potbellied stove. Fisch's department store was the ideal shop for Easter and Christmas outfits, while the soda fountain at Bunce & Carter's Drug Store specialized in refreshing ice cream sodas. Restaurants, too, were abundant and ranged from rib shacks to the West Side Tea Room, where local African American high school girls worked as waitresses.[139]

Former boxer Primo Carnera (left) at a wrestling match held in the Asbury Park Armory on January 17, 1948, with Michael Travers. Carnera's opponent that night was Buddy Rogers, aka Herman Rohde. *Courtesy Travers family.*

Growing up in nearby Bradley Beach, Bob Hopkins also remembers frequent shopping trips to the vibrant West Side during the 1950s. His father took him to a combination poultry market and bookie joint at Springwood and Railroad Avenues, where full-feathered live chickens clucked in cages. Bob pointed at one and was horrified when the butcher grabbed it, slit its throat and tossed it in a barrel, where it bounced around until dead. Then, the butcher took the bird out, dunked it in boiling water, plucked it, butchered it and wrapped it in brown paper. Bob rode home, sitting quietly in his father's station wagon, the chicken under his arm still warm and, in his mind, somehow still alive. His sisters, not knowing the back story, devoured the chicken that night, but Bob abstained.[140]

There was a meat market up the street from the poultry store, run by two Italian-American brothers, where the Hopkins family got bones for their dog—big hambones, with some meat still on. As in many frugal households of mid-twentieth-century America, where memories of the Depression were still fresh, the hambone made an initial stop in the family pea soup pot, the remaining meat boiled and scraped away before it was passed on to the dog. There was sawdust on the floor in the meat market to soak up blood, and when Bob looked at it he always thought of the death row caged chickens down the street.[141]

Then there was Fisch's, where you could get bargains on clothing and shoes, and down the street a bit was Cuba's Lounge, where music spilled out onto the street as shoppers passed by. There was always lots of music in Asbury, and much of the best of it was along Springwood Avenue.[142]

And of course, despite some early signs of decay, the boardwalk and beaches remained Asbury Park's prime asset, earning it titles such as the "Gem of the Jersey Shore." Coauthor Joseph Bilby clearly remembers his own little joys of that era. During the early 1950s, his parents and his father's cousin's family would rent a beachfront house in Manasquan for a week at the tail end of summer. That bittersweet week before Labor Day—when dread of the imminent school year and a Sister of Charity armed with a ruler at Saint Rose Grammar School all jumbled up with the sheer joy of wandering the beach prospecting for seashells, splashing in the surf and catching a fluke off a party boat deck—would end with a Friday evening ceremonial trip. The adults would pile the kids in the cars and drive north, parking in Ocean Grove and walking down the boardwalk under the arch of Clarence Hetrick's Casino and into James A. Bradley's Promised Land. Although the fabled boardwalk was starting to deteriorate, it was still a magic place to a kid from Newark, and with a frozen custard in hand, he would sprint off the boards and up Lake Avenue to Palace Amusements,

The Spanish Tavern on the West Side in the 1950s. *Courtesy Asbury Park Library.*

to take a turn on the teeth-rattling, spark-showering bumper cars and then at the shooting gallery fronting on Wesley Lake, with its slick pump action Winchester .22-caliber rifles—the constant crack and clang of the rifles and the metal duck targets going by, then down, only to get right up and sail by again. Seven shots for twenty-five cents it was, and for that you got crack and clang and the sweet smell of burnt smokeless powder when you jacked in another round. He came back again in 1961 on the Our Lady of the Valley High School senior trip and dumped a pocketful of quarters down on the counter. In another five years, he was an army second lieutenant many thousands of miles away, and the shooting was for real, but the boardwalk and the custard and the bumper cars and the rifles and the metal ducks of that slightly shabby Promised Land stuck in his mind and still do.

Even into the 1960s, Asbury possessed an enchanting appeal for many people. Giaconda Osnato, an eighty-one-year-old naturalized Italian-American from Rome, remembered Asbury Park as the ultimate destination for young lovers in 1967. Osnato, now living in Fiuggi, Italy, recalled that one of the most vivid memories of her life was of the time she, as a young American bride, spent a wonderful weekend with her late husband Edward Osnato in Asbury Park. Edward set up a mysterious rendezvous with Giaconda at the Berkeley-Carteret and, following a fine meal and evening stroll down the boardwalk, arranged a 4:00 a.m. wakeup call, much to his wife's surprise and bewilderment. Room service delivered breakfast and

Winchester model 62A .22-caliber rifle, loading tube and change-making device used at the Palace Amusements shooting gallery in Asbury Park, where coauthor Joseph Bilby dropped many a quarter for seven shots in the 1950s. Joseph Bilby photo. *Courtesy Steve Garratano collection.*

The Berkeley-Carteret Hotel in 2008. *Courtesy Joseph Bilby.*

The Fall and the Rise

Edward opened the curtains just as a speck of light broke the darkness. The couple held onto each other with excitement and awe as the sun rose slowly over the crashing Atlantic surf. For Mrs. Osnato, the memory of a sight that originally transfixed James A. Bradley has become ever more vivid with the passage of time.[143]

THE DOWNFALL

During this era of seemingly returned Asbury Park prosperity, however, trouble lurked underneath the veneer of success. Asbury was governed by men of seemingly limited vision and, at times, questionable ethics. George Smock II continued to promote the old concept of Asbury Park as resort and commercial center and apparently continued the old-time governance as well; there were investigations and indictments of members of his administration in the late 1940s for alleged Hetrick-style kickbacks and crony deals on town purchases and beach concession leases. There would be no big-time payoffs for anyone anymore, though. His city essentially bankrupt, the mayor posited no grand plans and actually attempted to repay Asbury's massive municipal debt while maintaining a shaky status quo in a world that was changing dramatically around him. Smock left office in 1955, and two years later his place was taken by another in the city's series of long-term mayors, Democrat Joseph Mattice. Formal political affiliation aside, Mattice continued the old guard's hegemony for another seventeen years. In 1973, running in the face of multiple corruption indictments, he finally lost an election and left city hall.[144]

In addition to faulty leadership, other problems were brewing. As early as the halcyon postwar years following World War II, perceptive observers could see that the end might well be coming. Returning GIs and their wives, emerging from a whole generation of depression and war, developed a yen for a home and a piece of land to call their own and an appetite for mobility that would eventually bring dramatic change to the patterns of everyday American and New Jersey life and diminish the desirability of Asbury Park as a residential and commercial center, as well as a resort.

Two enormous and ambitious road projects—the New Jersey Turnpike and Garden State Parkway—played into this scenario. Both postwar projects opened up distant parts of New Jersey to motorists, bypassing meandering country roads for quick access to key destinations. While the turnpike worked its way southwest from metropolitan New Jersey, however, the parkway was more of a direct threat since it paralleled the Jersey Shore and offered quick access to newer, glitzier resorts like Seaside Heights and Wildwood. When the Garden State Parkway

opened its last four miles in 1955, tying the Jersey Shore into its system, the playing field changed for competing vacation spots along the coast. Before the parkway cut through swaths of farmland in then rural Monmouth County, the main route to the Jersey Shore from North Jersey was the tedious drive along congested Route 9 to the Victory Bridge, a course that then merged into Route 35. The "shortcut" was to drive inland and head south via Route 34, through the rolling agricultural region of Colts Neck and other sparsely populated towns. With the parkway's debut, however, travel to remote parts of the Jersey Shore only involved a smooth ride along a neatly landscaped superhighway. Why settle for Asbury Park, with its rather sedate rides and ho-hum attractions, when one could find new diversions farther down the coast?[145]

In an endeavor to halt the exodus of vacationers, Asbury Park entrepreneurs attempted to expand the resort as an entertainment center, building on a long tradition that extended back to Arthur Pryor. With that in mind, and perceiving the beginnings of a new musical era, they booked Bill Haley and the Comets and other rock 'n' roll acts. The program suffered a fatal setback when Frankie Lymon and the Teenagers, a New York City group famed for their signature hit "Why Do Fools Fall in Love," highlighted by Lymon's distinctive and unforgettable falsetto voice, appeared at Convention Hall on June 30, 1956. The result was a series of inter- and intra-racial fistfights of undetermined origin that, while perhaps not constituting a genuine riot, spilled over into and caused damage to the city's commercial district. Although locals attributed the trouble to "outsiders" from Newark and/or the very nature of rock 'n' roll itself, author Daniel Wolff views the incident as indicative of the racial tensions that had been festering just below the surface in Asbury Park from the Bradley days.[146]

Even as the boardwalk's luster faded, Asbury began to lose its residential base, since many city dwellers were opting for the larger, newer homes being built on former farmland only a few miles away. And in 1960, much to the alarm of nearby small cities including Asbury Park, Red Bank and Long Branch, Monmouth Shopping Center—the future Monmouth Mall—opened at Eatontown Circle and Route 35. The site's original twelve stores included Bamberger's, Food Fair, S.S. Kresge, Lerner Shops and Miles Shoes. Several thousand people were on hand for the March 1 opening ceremonies, and the stores were crowded all day with an estimated 100,000 visitors. Asbury Park officials had already been scurrying to fight this formidable new competitor, building a $500,000 four-level parking facility in the center of the business district and planning shuttle bus service from the beachfront to downtown. But the unstoppable tides of change were in favor of suburbia and the malls that defined a new generation of shopper.[147]

The Fall and the Rise

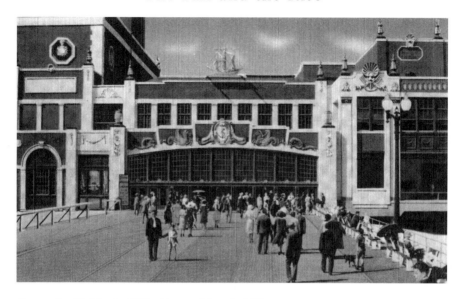

Convention Hall in the 1950s. *Courtesy Asbury Park Library.*

Other forces entered into the currents of change besieging Asbury Park, including the growing frustration of African Americans with the city's lack of social and economic progress, a frustration that became more violent and bitter in the 1960s. These feelings were apparent in numerous cities across the country, including Asbury, where black residents were still confined to the West Side and stymied by the lack of real opportunities. Generations of frustration exploded in racial rioting across New Jersey, beginning in Newark in July 1967 and rapidly spreading to Jersey City, Plainfield, New Brunswick and Paterson. Asbury Park's political leaders were nervous, but the fact that the town's first African American police chief, the capable Thomas Smith, was in charge gave officials hope that they could avoid a similar fate. They would not.

Although Asbury did not join in the violence rippling throughout the state in the summer of 1967, matters came to a head three years later. On the evening of July 4, 1970, a large gathering of black teens scuffled with police. Order was restored by early the next day, Sunday, but by dusk crowds began to reform. The situation was tense but manageable until shortly after midnight, when a group of about seventy-five teenagers broke into the Neptune Diner on Springwood Avenue. Police barricaded Springwood from Main Street—the dividing line between black and white Asbury—and the crowds forming along Springwood erupted into a wave of destruction. In a frenzy of looting, people hurled rocks into the windows of shops and helped themselves to the merchandise.[148]

As the rioting continued into the morning of July 6, city officials declared a state of emergency, calling on police from throughout the area for help. Within hours, the situation was declared under control, with twenty people arrested. But by noon, fights had erupted again, and a fire broke out that destroyed the landmark's Fisch's department store.[149]

Trouble continued late into the afternoon of Tuesday, July 7, when a crowd of about two hundred black youths in their teens and early twenties gathered on the West Side just south of the railroad station. The youths were clearly agitated, reiterating the complaints of previous days over inequalities in housing, schooling and job opportunities. They were especially angry that day over what they considered discrimination in the summer job market along the beachfront. White teens were getting the most pleasant and highest-paying jobs in Asbury's hotels and restaurants, they said. "What's left for us is the lousy dishwasher jobs," a black teen told a *TV Guide* reporter.[150]

The crowd started to throw rocks and bottles at store windows and moved restlessly toward downtown. As police ranks gathered to respond, the officers found themselves pelted with a variety of objects. "Some gasoline bombs were starting to come over, too," said Special Officer Patrick Barrett. "But we weren't replying in any way." Not all agreed with Barrett's account. Some eyewitnesses said police retaliated in anger to the latest surge of rioting, injuring others needlessly. Radio-TV reporter Dell Wade, for example, related a shocking story of police brutality and Gestapo-style efforts to hide the truth. He appeared on-screen with his head bandaged and face bruised and told of seeing police firing into crowds and clubbing people. In response to such stories of unacceptable conduct, however, there was a backlash of disbelief and anger. "City and area residents are generally expressing disgust with television news coverage of the disorders," wrote a reporter from the *Asbury Park Press*. "They complain of erroneous questions, slanted editing, leading questions, inflammatory comments."[151]

The divisiveness in opinion only served to aggravate tensions in the beleaguered city. Although rioting had subsided by Saturday, July 11, the devastated Springwood Avenue was an open wound that served as a disturbing visual reminder of the divide between most of Asbury Park's black and white populations. Overall, 180 persons had been injured, 167 arrested and property damage had reached $4 million.[152]

For West Side residents like Renee Freeman, the riots signaled the tragic end of a golden era. "After the riots, people who did not live in the area no longer wanted to come to the dreaded Springwood Avenue; so many of the stores lost customers and gradually closed," she said. "Buildings were demolished and now on that same grand street are only ghosts of what used to be."[153]

The Fall and the Rise

The years that followed were ones of continued decay and embarrassment. Asbury was now known as a prime example of urban unrest, connected more with disturbing images of fires and looting than of Ferris wheels and sunny beaches. Like the aging actress Norma Desmond in the movie *Sunset Boulevard*, Asbury was becoming a haunting relic from the past, coasting along into oblivion on memories of former greatness.

In 1975, the scars from the riots were still fresh and Asbury Park was "still rundown," according to a *New York Times* report. While bulldozers continued to clear rubble along Springwood Avenue in anticipation of an urban renewal project, city leaders fretted about Asbury's bleak housing and employment situation. Almost 60 percent of the housing was at least thirty-five years old, and 13 percent of it had been labeled "substandard" by the Monmouth County Planning Board. There was a waiting list of more than 1,100 families for space in the one thousand low-income rental units. Lack of jobs was also a problem, with overall unemployment in the city running at 18 percent. As if to illustrate the issue, groups of aimless, unemployed young men clustered in and around hangouts like the Sunny Hunny Restaurant.[154]

Samuel Addeo, head of the city's Department of Community Affairs, was blunt in his assessment of Asbury's woes. "We've got it all," he said. "The flight of the middle class, really difficult budget problems, a deteriorating central business district, high crime rates, drug traffic and all the rest." Meanwhile, black leaders like Willie Hamm, an administrator at Rutgers University who helped to forge a coalition of West Side civic groups into an influential political force, worried about the mood of the town. Hamm noted that the black community had been hit especially hard by the country's overall economic recession and what he regarded as overly aggressive patrol activity by the city's police department. "People are very sensitive to police activity," he said. Police, on the other hand, were angry about what they regarded as overwork and low pay. Yet there was some hope, officials noted. Hamm pointed out that there had been real progress in the two years since a heavy West Side vote had enabled Dr. Lorenzo W. Harris to become the first African American member of the city council. In addition, Harris's active lobbying against former mayor Joseph Mattice played a role in the latter's ouster from office. Mattice, under indictment for conspiring to control the city's Democratic committee, was replaced as mayor by Ray Kramer. The elections "made for much more open and responsive government, and I'm not just saying that because I'm in it," Harris said at the time.[155]

Yet the city's decline continued. One by one, the great monuments to its past disappeared. One of the most poignant moments of the 1970s was the razing of the magnificent Mayfair, the movie palace that drew hundreds

of admirers to its grand opening in 1927. In 1974, the Walter Reade Organization announced plans to demolish the Mayfair and its neighboring theatre, the St. James. "The harsh reality of today's economy in this energy crisis world precludes the possibility of efficiently remodeling or modernizing them," said Sheldon Gunsberg, president of the organization. Despite the efforts of the Save the Mayfair Committee, which offered $100,000 for the structure, the demolition moved forward. "Mayfair to die Thursday," the *Asbury Park Press* mournfully declared on December 3, 1974.[156]

With the 1979 closing of Steinbach's at Press Plaza, the bustling heart of downtown Asbury lost another of its mainstays. The *Asbury Park Press* lingered into the early 1980s and then picked up and relocated to a gleaming new corporate headquarters in nearby Neptune in mid-decade. Press Plaza came to resemble an abandoned movie set, desolate and forlorn on weekdays that used to see it filled with people. Streetwalkers worked Main Street, and former motels and rooming houses were converted into halfway houses for deinstitutionalized psychiatric patients, and their presence discouraged even more people from venturing into the city. In 1975, 15 percent of Asbury Park's residents were unemployed, and the city's remaining labor market rapidly eroded during the 1980s.

STEPS FORWARD, THEN BACK

Yet while downtown Asbury faded, and its streets remained empty during the day, the city's nights still drew crowds, although of a different nature from years before. College students, rock musicians and gays and lesbians became the new clientele of nighttime Asbury, drawn to a freewheeling club scene that went full tilt into the early morning hours.

Perhaps one of the earliest examples of Asbury's raucous night scene was the Circuit, the parallel roads of Ocean and Kingsley Avenue that teens would drive along for hours at night, in a scene reminiscent of films like *American Graffiti*. As early as the 1940s, riding the circuit was an important coming-of-age ritual for many Jersey Shore youths. During that time, teens called it "cruisin' the 'bury," recalled Neptune resident Bob Pontecorvo. And cruise it they did, from Neptune into Asbury Park, down Cookman Avenue and then Ocean and around to Kingsley and back again—and again. It was a place to see and be seen, to meet friends, and anyone who wanted to get noticed spent the weekend evenings cruisin' in a car packed with as many kids as you could cram into it. Bob and his twin brother, unwitting participants in the birth of American teenage culture, had a 1931 Model

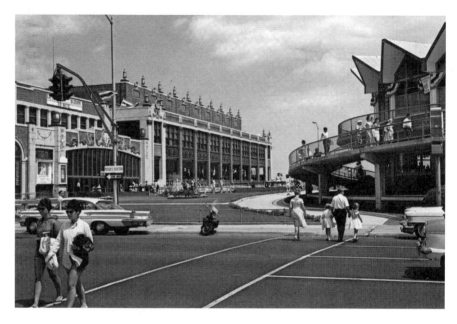

Convention Hall and a Howard Johnson's restaurant, at right, circa 1965. *Courtesy Asbury Park Library.*

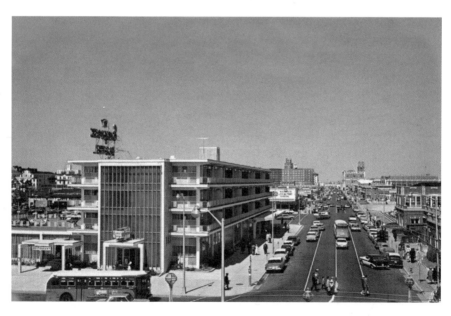

A view down Ocean Avenue, looking north in the early 1960s. *Courtesy Asbury Park Library.*

A Ford, and they made it an impromptu convertible by sawing the top off. They did a neat job and had the seats reupholstered, but it was less than perfect in the rain. No matter. It served the purpose of "cruisin' the 'bury." The Korean War came, and the brothers went into the army. Later, the war over and now of legal drinking age, Bob decided to celebrate by having a drink in every bar in Asbury Park. He had to quit halfway through. James A. Bradley would have been appalled.[157]

In addition to the appeal of simply cruising around the nighttime streets of Asbury, the city boasted a thriving club scene centered on rock music. By the early '70s, Asbury's night scene had acquired a distinct musical identity, forged in part by the regular gatherings of an eclectic group of musicians at an obscure little Cookman Avenue club called the Upstage. Here, at the end of a steep flight of stairs above the Green Mermaid coffeehouse, fledgling performers like Davey Sancious, Steve Van Zandt and an intense young man with shoulder-length hair by the name of Bruce Springsteen practiced their craft. Bob Hopkins remembered a trip to the Upstage during that era, when he listened to Springsteen and his band. The "kid" was good, Hopkins recalled, and he loaned someone in the band five dollars, although he forgets whom. "Maybe Springsteen owes me five bucks," he said with a chuckle, remembering his brush with fame.[158]

The fortune-telling booth of "Madame Marie," celebrated in song, still stands on the boardwalk as a living memory of an older Asbury Park. *Courtesy Joseph Bilby.*

The Fall and the Rise

It was Springsteen, then an ambitious unknown from Freehold whose band Steel Mill played in Asbury clubs such as the Sunshine Inn, who would put Asbury on the musical map. In 1972, when his first album, *Greetings from Asbury Park*, was released, it was met "with the most extravagant and outrageous praise I've ever encountered in the Rock Press," observed *New York Times* writer Bruce Pollock. "If superlatives were a dime a dozen, Springsteen could have retired then and there." Instead, the prolific artist followed up a year later with *The Wild, the Innocent & the E Street Shuffle*, which Pollock described as another "howling, joyous monster of a record." Together, these two albums helped to shape a powerful mythology of Asbury Park as a colorful nighttime world of adolescent fantasies and fears. Songs such as "Sandy," about the carnival summertime life on Asbury's boardwalk, made the city almost as much of a celebrity as Springsteen. Other talented bands, including Southside Johnny and the Asbury Jukes, helped to cement Asbury's reputation as fertile ground for gritty musicians with a penchant for straightforward, heartfelt lyrics. Andrew Jeffreys, a young man drawn to Asbury's mid-'70s music scene, spoke for many of his fellow rock fans when he noted in a newspaper opinion piece that people were drawn to the honesty of the Asbury sound. "These guys gained their experience by playing the cheap Jersey Shore bars, and not the slick Greenwich Village coffeehouses in New York," he wrote. The crowds came to hear Asbury's "honest" sound, and beachfront bars, most notably the landmark Stone Pony on Ocean Avenue, were jammed with young people out for a night of good music and good times.[159]

The aging resort also drew increasing numbers of gay men and women as the 1970s continued. Pleasure seekers from New York and Philadelphia were drawn to a cluster of bars that emerged in the early and mid-'70s, making Asbury an "in spot" for the newly visible group of gays and lesbians. Tourists flocked to the bars that lined the east end of Cookman Avenue, including the Odyssey, Archie's and the M&K, a glittering disco club housed in the former Charms Building. On warm summer nights, patrons walked casually from club to club, while an insistent "thump" of dance music blared from bars, radios and 8-tracks. The thriving nightlife, however, did little for Asbury's economic health as a whole. During the day, the city was a shell of its former self. As the '70s morphed into the '80s, little seemed to change.

In fact, the 1980s and '90s proved to be exceptionally frustrating times for Asbury Park. In 1984, the city embarked on a redevelopment plan that focused on replacing Asbury's party town image with the idea of a residential city and modern first-class resort destination. Two local brothers, Henry and Sebastian Vaccaro, became heavily involved in the city's efforts to revive

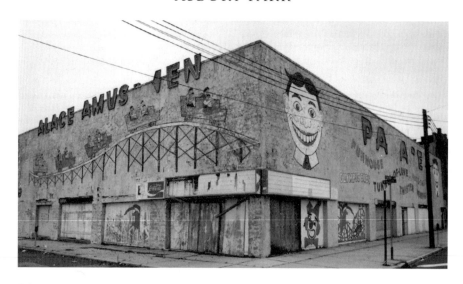

Palace Amusements in the 1980s. *Courtesy Harry Ziegler.*

itself, a valiant struggle that ultimately amounted to nothing. The brothers first bought the deteriorating Berkeley-Carteret. They renovated the building and claimed that it was operating at 70 percent capacity. In 1986, City Manager Sam Addeo signed a $500 million contact with the Vaccaros for construction of 2,400 residential units between Grand Avenue and the beach. The Vaccaros represented only one-third of the deal, however; the bulk of the financing and construction went to Carabetta Enterprises of Meriden, Connecticut, which had been responsible for building thousands of federally subsidized apartments in New England.[160]

The future looked promising, but not for long. In 1989, the Vaccaros pulled out of the deal, and Carabetta bought their shares. Then Carabetta was sideswiped by a series of financial setbacks and filed for Chapter Eleven bankruptcy in 1992, while refusing to give up its exclusive rights to build on the waterfront. Thus, Asbury's beaches, boardwalk and former hotel district, once the "Gem of the Jersey Shore," became a desolate wasteland of unfinished condos, some of which burned to the ground in true old-time Asbury Park fashion.[161]

To aggravate the depressing situation, media images of decay and desolation continued to pull Asbury down. In 2002, many Asbury supporters were disgruntled when *City by the Sea*, a movie set in a run-down Long Island city but filmed in Asbury Park, premiered. The gritty film featured the star power of Robert De Niro, but what most local people remembered was its unflattering portrayal of their city. Set designers littered the boardwalk and

its buildings with debris and called in graffiti artists from the Bronx to make Asbury appear even seedier than it was. "The woman who worked in their set design asked me where to go for the dreariest sites in town," said shop owner Louis Navarete. "They were having a problem finding places that were hideous."[162]

THE ROAD UP

Yet despite all of the negative publicity, positive momentum slowly began to take hold. A handful of art galleries and antique stores began to spring up on Cookman, and over a two-year period property values rose by about a third as home buyers took advantage of residential bargains. By 2003, the revival was strong enough to warrant an in-depth article in the *New York Times* about the city's emerging restaurant scene. Although the oceanfront remained a "ruin of weedy lots, splintered boardwalk and unrealized urban renewal," a small but persistent group of entrepreneurs were carving a niche in the abandoned downtown, much as their predecessors had done more than a century ago. The group was a diverse mix of gay and straight, black, white and Hispanic. They shared a conviction in the possibilities of a town that many locals still referred derisively to as "Beirut," a wartorn comparison that came readily to mind when the city was viewed from the sea.[163]

Two of the ambitious businessmen were Luke Magliaro and Howard Raczkiewicz, owners of the successful Moonstruck restaurant in neighboring Ocean Grove. They set their sights on a dilapidated frame house overlooking Wesley Lake. When they told customers and friends of their plans to move Moonstruck to Asbury Park, they were greeted with skepticism and concern. The pair moved forward, opening their $2 million establishment in 2002. On a July evening in 2003, the *New York Times* writer noted, the parking lot was filled with Mercedes and BMW automobiles. "We're changing people's opinion of Asbury Park, one car at a time," Raczkiewicz said.[164]

Although some of the restaurants cited in the *New York Times* article failed, Moonstruck continued to operate successfully, joined by other business that began to renew neglected Cookman Avenue. By 2008, many of the avenue's storefronts were renovated, and the street offered an eclectic selection of shops, ranging from antique emporiums to an upscale pet boutique. Even the Steinbach building, which stood like an abandoned monument for decades, was restored, with a branch of the popular New Brunswick restaurant Old Man Rafferty's on its ground floor and high-end lofts above. As in days of old, city promoters conjured up creative ways to lure customers into town,

The corner of Cookman and Mattison Avenues in 2008. *Courtesy Joseph Bilby.*

such as a "First Night" on the first Saturday of each month, featuring a variety of themed celebrations and promotions.

James Kaufman, owner of Flying Saucers, a retro kitchenware store on Cookman Avenue, said he was inspired to open his business there in 2007 after witnessing the excitement and potential of Asbury's downtown during one of the city's "First Nights." Kaufman, a lifelong Jersey Shore resident, witnessed the city during its better days in the mid-'60s, as well as during its painful decline in the years that followed. For him, it was gratifying to be a part of the fledgling downtown renaissance that built upon the city's rich traditions of commerce. "Asbury is in a state of flux, and we need to be aware of the legacy of the past as we make the city into a progressive community of the future," he said. Today, Kaufman's store, a colorful mix of mid-twentieth-century kitchen items, is one of the many unique shops that lure customers from throughout the region.[165]

In addition, the beachfront, for years an eerie landscape of shuttered concession stands and an abandoned boardwalk, began to experience a renaissance. In 2001, Asbury Partners bought Carabetta's redevelopment rights and properties, moving on to also purchase Convention Hall, pavilions, the Casino and the heating plant, while the city retained ownership of the boardwalk. In 2005, Asbury Partners reopened the Casino arcade walkway, allowing pedestrian access from Ocean Grove and points south to their

The former Howard Johnson's on the boardwalk. The restaurant, now remodeled and under new ownership, was originally built as part of the Fifth Avenue Pavilion in 1961. *Courtesy Joseph Bilby.*

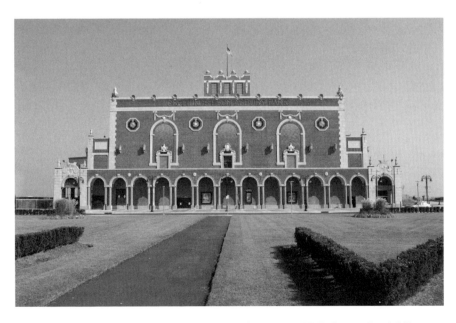

Founder Bradley's 2008 view of Mayor Hetrick's Convention Hall. *Courtesy Joseph Bilby.*

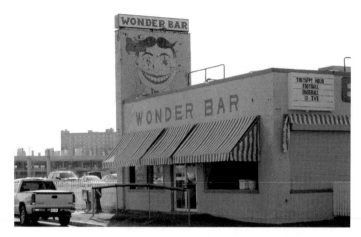

The last image of Tilley on public display in town is on the Wonder Bar on Ocean Avenue. *Courtesy Joseph Bilby.*

newly rebuilt boardwalk, and a dozen concessions opened to serve the influx of new customers. The following year, Madison Marquette joined Asbury Partners in a joint venture to develop boardwalk and seaside buildings as part of a new entertainment and retail sector.[166]

By the summer of 2008, the boardwalk was again abuzz with energy and excitement. As businessmen waited to see whether the Madison Marquette plan would come to fruition, numerous shops were already in operation, many with the hopes of being in the final mix of national and local retail tenants if the Marquette project becomes a reality. The eclectic group of establishments ranged from chic art galleries to a waterfront Tiki bar. On a brilliant, sunny August Sunday, swarms of people walked from store to store or lolled contentedly on the beach. A month later the boardwalk was still full of Sunday visitors, and some, including Jodie and Philippe Lepine, two tourists from France, even sauntered over to take a look at James A. Bradley, still standing and staring at Convention Hall. The size of the crowds may not have matched the many thousands of Bradley's day, but the numbers were substantial nevertheless.

On those promising late summer Sundays, it was clear that the road ahead was uncertain, but many indicators pointed to perhaps yet another rebirth in Asbury Park's long and fascinating saga of challenge and change. As the city lurched with fits and starts through the end of the twentieth century and into the first decade of the twenty-first, sometimes taking two steps forward and one step back, it seemed that good things were finally beginning to happen again in Asbury Park. Whatever the end result, if the past is any indicator, it will no doubt be an interesting ride.

The Promised Land may still be.

NOTES

CHAPTER 1

1. Bradley Memorial Committee, "Associated Reporters," *James A. Bradley and Asbury Park* (Asbury Park, NJ: Bradley Memorial Committee, 1921). Hereafter cited as "Associated Reporters," *James A. Bradley*.
2. Lewis Historical Publishing Company, *History of Monmouth County, New Jersey, 1664–1920*, vol. III (New York and Chicago: Lewis Historical Publishing Company, 1922), 206; "Associated Reporters," *James A. Bradley*.
3. "Associated Reporters," *James A. Bradley*.
4. Thomas A. Bailey, *The American Pageant: A History of the Republic*, 3rd ed. (Boston: D.C. Heath and Company, 1966), 402–3.
5. *Asbury Park Shore Press*, May 21, 1885.
6. Ibid.
7. *Asbury Park Shore Press*, May 21, 1885; Glenn Uminowicz, "Recreation in Christian America: Ocean Grove and Asbury Park, New Jersey, 1869–1914," in Kathryn Grover, ed. *Hard at Play, Leisure in America 1840–1940* (Amherst: University of Massachusetts, 1992), 10–11, 18–19.
8. Gustav Kobbe, *The Jersey Coast and Pines* (Baltimore: Gateway Press reprint, 1970), 45–46; Asbury Park *Shore Press*, May 21, 1885. The "sheet of water" was probably either today's Wesley or Sunset Lake.
9. Uminowicz, "Recreation in Christian America," 25; Russell Roberts and Rich Youmans, *Down the Jersey Shore* (New Brunswick, NJ: Rutgers University Press), 102.
10. *Asbury Park Shore Press*, May 21, 1885.
11. Joseph Eid, *Trolleys in the Coast Cities* (privately published, 1979).

12. *Asbury Park Shore Press*, May 21, 1885; "Associated Reporters," *James A. Bradley.*

13. *New York Times*, July 12, 1891; August 6, 1895; July 28, 1905.

14. "Associated Reporters," *James A. Bradley.*

15. *New York Times*, August 9, 1911.

16. *New York Times*, August 6, 1895.

17. *New York Times*, July 11, 26, 1888; David G. Martin, ed. *The Monocacy Regiment: A Commemorative History of the Fourteenth New Jersey Infantry in the Civil War, 1862–1865* (Hightstown, NJ: Longstreet House, 1987), 295.

18. Margaret Thomas Buchholz, *Shore Chronicles: Diaries and Travelers' Tales from the Jersey Shore, 1764–1955* (Harvey Cedars, NJ: Down the Shore Publishing, 1999), 194–96; Daniel Wolff, *4th of July Asbury Park: A History of the Promised Land* (New York: Bloomsbury, 2005), 60. For an astute analysis of Asbury Park's influence on Stephen Crane's work, see Wolff.

19. *New York Times*, November 11, 1883; July 12, 1886.

20. *New York Times*, "Founder Bradley Opposed to Cupid," August 16, 1891; "Associated Reporters," *James A. Bradley and Asbury Park.*

21. Wolff, *4th of July*, 33; Morris family papers, "The Sea Girt Encampment," Monmouth County Historical Association, folder #1; Helen-Chantal Pike, *Asbury Park's Glory Days: The Story of an American Resort* (New Brunswick, NJ, Rutgers University Press, 2005), 17.

22. *Asbury Park Journal*, July 17, 1885; Wolff, *4th of July*, 34–35.

23. Wolff, *4th of July*, 36–38.

24. Ibid., 41–42.

25. *New York Times*, June 28, 1887; Wolff, *4th of July*, 45–47; Joseph G. Bilby, *Forgotten Warriors: New Jersey's African American Soldiers in the Civil War* (Hightstown, NJ: Longstreet House, 1993) 45.

26. Wolff, *4th of July*, 76.

27. Charles E. Funnell, *By the Beautiful Sea: The Rise and High Times of That Great American Resort, Atlantic City* (New Brunswick, NJ: Rutgers University Press, 1983), 29–30.

28. E-mail from Carol Grissom to Joseph Bilby, August 28, 2008.

29. Kobbe, *The Jersey Coast and Pines*, 46; Caldwell K. Hall was lieutenant colonel of the Fourteenth New Jersey Infantry, a unit partially raised in Monmouth County. He was severely wounded at the battle of Monocacy on July 9, 1864, and left the service due to disability. Martin, *The Monocacy Regiment*, 252; Pike, *Glory Days*, 175; Shirley Ayres, *Postcard History Series: Asbury Park* (Charleston, SC: Arcadia Publishing), 105.

30. Major General William S. Stryker, *Report of the Adjutant General of the State of New Jersey for 1898* (Trenton: MacCrellish & Quigley, 1899), 24; *Asbury Park Press*, April 25, 1948.

31. William Edgar Sackett, *Modern Battles of Trenton, Being a History of New Jersey's Politics and Legislation from the Year 1868 to the Year 1894* (Trenton: John L. Murphy,

1895), 458; Reynolds A. Sweetland and Joseph Sugarman Jr., *Entertaining a Nation: The Career of Long Branch* (Long Branch, NJ: City of Long Branch, 1940), 94.

32. *New York Times*, December 29, 1894.

33. Ibid.

34. John T. Cunningham, *New Jersey: A Mirror on America* (Florham Park, NJ: Afton Publishing, 1956) 248–49.

35. *New York Times*, September, 26, 1897.

36. *New York Times*, October 11, 1894.

37. Lee Ellen Griffith, "Arthur Augustus Zimmerman" in Maxine N. Lurie and Marc Mappen, eds., *Encyclopedia of New Jersey* (New Brunswick, NJ: Rutgers University Press, 2004), 893.

38. *New York Times*, July 30, 1893.

39. *New York Times*, July 9, 11, 1895.

40. Ibid.

41. Ibid.

42. Ayres, *Asbury Park*, 122.

43. *New York Times*, July 22, 1890.

44. *New York Times*, August 22, 1897.

45. *New York Times*, August 22, 1901.

46. Grover, *Hard at Play*, 29; Pike, *Glory Days*, 69.

47. Pike, *Glory Days*, 48–49.

48. *New York Times*, June 12, 1904.

49. Ibid.; Wolff, *4th of July*, 77–82; "Associated Reporters," *James A. Bradley*.

50. *New York Times*, June 12, 1904.

51. Pike, *Glory Days*, 45; Wolff, *4th of July*, 75; *New York Times*, August 30, 1908.

52. *New York Times*, July 7, 1907.

53. Ibid.

54. Ibid.

55. Ibid.

56. Ibid.

57. Pike, *Glory Days*, 47–48.

58. Ibid., 50–51; *Asbury Park Journal*, February 20, 1906.

59. Wolff, *4th of July*, 85–87; Pike, *Glory Days*, 18–19; *Asbury Park Journal* , May 11, 15, 1906.

Chapter 2

60. *New York Times*, October 14, 1941; Lewis Historical Publishing Company, *History of Monmouth County*, vol. III, 207; *Van Wert (OH) Daily Bulletin*, April 19, 1915; Pike, *Glory Days*, 19.

61. Pike, *Glory Days*, 19; *New York Times*, November 15, 1910; "Murder in Monmouth," http://co.monmouth.nj.us/page.asp?agency=9&Id=1679#MIN GO; *Asbury Park Evening Press*, November 1, 15, 1910; *Shore Press*, November 13, 1910; *New York Times*, October 14, 1941.

62. *New York Times*, December 3, 1910.

63. *New York Times*, March 16, 1911; Hetrick had successfully canvassed the African American vote previously, however, winning the Republican primary for city treasurer in 1906 with a 175-to-11 vote majority in the "Springwood Avenue District." *Van Wert (OH) Daily Bulletin*, October 2, 1906.

64. *New York Times*, October 14, 1941; *Van Wert (OH) Daily Bulletin*, April 19, 1915; Pike, *Glory Days*, 28–30, 175–76; *History of Monmouth County*, vol. III, 207; Hetrick had somewhat of a reputation of a ladies' man, and there was, according to some, a "flirtation" with King. Interview of September 23, 2008.

65. Asbury Park Bureau of Publicity, *Asbury Park: Seashore and Country Combined; Come to the Beauty Spot of the North Jersey Coast: Absolutely Free of Mosquitoes* (Asbury Park, NJ: Bureau of Publicity, 1908); Thomas C. Whitlock, ed., *Asbury Park, Commercial Center of the North Jersey Coast* (Asbury Park, NJ: Asbury Park Chamber of Commerce, 1915).

66. Ibid.

67. Lieutenant Colonel Edgar M. Bloomer, "Historical Sketch of the New Jersey National Guard," in State of New Jersey, *Historical and Pictorial Review, National Guard of the State of New Jersey* (Baton Rouge, LA: Army and Navy Publishing, 1940), xxxi; Pike, *Glory Days*. 116–18, 175; *History of Monmouth County*, vol. III, 208; *Asbury Park Evening Press*, April 6, 1917.

68. Wolff, *4ᵗʰ of July*, 97; Interview of September 23, 2008.

69. Interview of September 23, 2008; Pike, *Glory Days*, 23; C.F. Taylor, MD, A.L. Russell, MD, J.C. Rommell, MD, eds., *The Medical World, Vol. xxxi, 1913* (Philadelphia: The Medical World, 1913), 502.

70. George Joynson, *Murder in Monmouth: Capital Crimes from the Jersey Shore's Past* (Charleston, SC: The History Press, 2007), 57–59, 64–68.

71. Wolff, *4ᵗʰ of July*, 102–3.

72. David M. Chalmers, *Hooded Americanism: The History of the Ku Klux Klan* (New York: Doubleday & Company, 1965), 28–30; Mark Sullivan, *Our Times: The United States, 1900–1925*, vol. VI, *The Twenties* (New York: Charles Scribner's Sons, 1935), 546–47.

73. John Higham, *Strangers in the Land: Patterns of American Nativism, 1860–1925* (New Brunswick, NJ: Rutgers University Press, 1955), 57, 80.

74. Chalmers, *Hooded Americanism*, 27, 31–32.

75. William Edgar Sackett, *Modern Battles of Trenton: Being a History of New Jersey's Politics and Legislation from the Year 1868 to the Year 1894* (Trenton: John L. Murphy, 1895) 112–15.

76. Sullivan, *Our Times*, vol. II, *America Finding Herself*, 92; Robert D. Bole and Laurence B. Johnson, *The New Jersey High School: A History* (New York: D. Van Nostrand, 1964), 42.

77. Chalmers, *Hooded Americanism*, 243; *New York Times*, February 16, 1923; May 31, 1926. For a succinct and accurate account of Ku Klux Klan activities in New Jersey, see Bernard Bush, "Ku Klux Klan," in Maxine N. Lurie and Marc Mappen, *Encyclopedia of New Jersey* (New Brunswick, NJ: Rutgers University Press, 2004) 446–47.

78. Chalmers, *Hooded Americanism*, 246, 251–52; Higham, *Strangers in the Land*, 59.

79. Sweetland and Sugarman, *Entertaining a Nation*, 136; Chalmers, *Hooded Americanism*, 244.

80. Chalmers, *Hooded Americanism*, 245; *Frederick (MD) Daily News*, June 26, 1923.

81. *New York Times*, April 7, 1924.

82. Ibid.

83. Wolff, *4ᵗʰ of July Asbury Park*, 100.

84. *New York Times*, August 5, 1924.

85. Chalmers, *Hooded Americanism*, 250; *New York Times*, February 15, 1947.

86. Higham, *Strangers in the Land*, 327–28; Sweetland and Sugarman, *Entertaining a Nation*, 136–37; Chalmers, *Hooded Americanism*, 248–49; *Hopewell (NJ) Herald*, October 19, 1927.

87. *New York Times*, July 23, 1928.

88. Ibid.; June 2, 1928.

89. Chalmers, *Hooded Americanism*, 251; *New York Times*, April 1, 1927.

90. Sullivan, *The Twenties*, 357.

91. Ibid.

92. Pike, *Glory Days*, 56.

93. Ibid., 58, 61.

94. "List of United States Citizens for the Immigration Authorities, *SS Bremen* Sailing from Southhampton, December 19, 1933, Arriving at Port of New York, December 22, 1933," United States Federal Census for 1930, Asbury Park; Wolff, *4ᵗʰ of July*, 116–17; *New York Times*, October 14, 1941; Pike, *Glory Days*, 155.

95. The Progressive Citizens' League of Asbury Park, *The Story of Asbury Park: The Record of Progress and Achievement, 1916–1931* (Asbury Park, NJ: reprint by Asbury Park Historical Society, 2002).

96. Wolff, *4ᵗʰ of July*, 119–23; Pike, *Glory Days*, 177.

97. *New York Times*, April 11, 1935.

98. Brian Hicks, *When the Dancing Stopped: The Real Story of the Morro Castle Disaster and its Deadly Wake* (New York: Free Press, 2006), 105–06.

99. Joseph G. Bilby, *Sea Girt, New Jersey: A Brief History* (Charleston, SC: The History Press, 2008), 82–86; Hicks, *When the Dancing Stopped*, 119, 157.

100. Hicks, *When the Dancing Stopped*, 157–58.

101. Ibid., 161–64.

102. Ibid., 164–65.

103. *New York Daily News*, September 10, 1934; Hicks, *When the Dancing Stopped*, 181, 187, 210–12.

104. Wolff, *4ᵗʰ of July*, 128–30; *New York Times*, April 11, 1935; Pike, *Glory Days*, 13; *Coaster*, June 12, 2003.

105. *New York Times*, July 4, 1935; October 25, 1935.

106. Bilby, *Sea Girt*, 73–81; Pike, *Glory Days*, 59.

107. Charles E. Funnel, *By the Beautiful Sea: The Rise and High Times of that Great American Resort, Atlantic City* (New Brunswick, NJ: Rutgers University Press, 1983), 145; Martin Paulson, "Enoch L. Johnson," in Lurie and Mappen, eds., *Encyclopedia of New Jersey*, 432.

108. *Asbury Park Evening Press*, July 7, 1941; Sweetland and Sugarman, *Entertaining a Nation*, 137.

109. John K. Mahon, *History of the Militia and National Guard* (New York: Macmillan, 1983), 179–80; *Asbury Park Evening Press*, December 16, 1941.

110. Robert Kurson, *Shadow Divers* (New York: Random House, 2004), 235.

111. Governor's War Cabinet Minutes, March 2 and 24, 1942, New Jersey State Archives, http://www.njarchives.org/links/guides/szwaa001.html.

112. Mark Edward Lender, *One State in Arms: A Short Military History of New Jersey* (Trenton: New Jersey Historical Commission, 1991), 88–89.

113. Governor's War Cabinet Minutes, April 9 and 24, 1942; May 4 and 19, 1942.

114. Ibid., June 9 and 16, 1942; November 10, 1942.

115. Ibid., July 28 and August 11, 1942; *Asbury Park Press*, September 22, 2002.

116. Woolf, *4th of July*, 140.

117. *Asbury Park Evening Press*, September 8 and 9, 1942.

118. *Asbury Park Press*, September 25, 2000, November 26, 1967.

119. Ibid., 141.

CHAPTER 3

120. *Asbury Park Press*, July 8, 1979; Pike, *Glory Days*, 143.

121. *Asbury Park Journal*, May 12, 1906.

122. Ibid.

123. *Asbury Park Press*, July 8, 1979.

124. Ibid.

125. Ibid.

126. Ibid.

127. Ibid.

128. Ibid.

129. Pike, *Glory Days*, 139.

130. Alan Pine, Jean Hershenov and Aaron Lefkowitz, *Peddler to Suburbanite: The History of the Jews of Monmouth County NJ* (Monmouth Jewish Community Council, 1991), 66–70.

131. Ibid.

132. Ayres, *Asbury Park*, 118, 121.

133. *Asbury Park Press*, August 6, 1927.

134. Ibid.

135. Ibid.

136. "Citizen's League," *Asbury Park*.

137. "Citizen's League," *Asbury Park*; *Monmouth Pictorial*, December 1937, 52–53.

138. "Citizen's League," *Asbury Park*.

139. *Asbury Park Press*, February 6, 1990.

140. Interview with Bob Hopkins, October 17, 2008.

141. Ibid.

142. Ibid.

143. Interview with Michelle Nice, October 17, 2008.

144. Wolff, *4th of July*, 140–42.

145. Ibid., 142–43; Federal Writers' Project, *New Jersey: A Guide to Its Present and Past* (New York: Viking, 1939), 552, 558.

146. Wolff, *4th of July*, 156–58.

147. *New York Times*, March 2, 1960.

148. *TV Guide*, September 26, 1970.

149. Ibid.

150. Ibid.

151. Ibid.

152. Ibid.

153. *Asbury Park Press*, February 6, 1990.

154. *New York Times*, August 11, 1975.

155. Ibid.

156. *Asbury Park Press*, September 26, 1974; December 3, 1974.

157. Interview with Bob Pontecorvo, September 30, 2008.

158. Wolff, *4th of July*, 173–74; Interview with Bob Hopkins, October 17, 2008.

159. *New York Times*, December 16, 1973; July 18, 1976.

160. Wolff, *4th of July*, 221–24.

161. Ibid., 225.

162. *New York Times*, September 15, 2002.

163. *New York Times*, July 6, 2003.

164. Ibid.

165. Interview with James Kaufman, October 18, 2008.

166. *Asbury Park Press*, October 18, 2008.

BIBLIOGRAPHICAL NOTES

Full citations on all sources used in this book are available in the footnotes, but the authors would particularly like to direct the reader interested in pursuing different aspects of the Asbury Park story in depth to several excellent recent works, including Daniel Wolff's *4th of July, Asbury Park*, a detailed study of the town's social history, particularly regarding race relations and music. Helen-Chantal Pike's *Asbury Park's Glory Days: The Story of an American Resort* is chock-full of never-before-seen pictures and primary source personal reminiscences of Asbury Park's people. Madonna Carter Jackson's *Asbury Park: A West Side Story* features more than two hundred West Side photos, taken from her father Joseph A. Carter Sr.'s extensive collection of images. Mr. Carter was a professional photographer who documented Asbury Park's African American community over a forty-year period beginning in 1940. Bradley Beach librarian Shirley Ayres provides over two hundred views of the city over a one-hundred-year period in her postcard history, *Asbury Park*. Brian Hicks covered the *Morro Castle* fire in great detail in his *When the Dancing Stopped: The Real Story of the Morro Castle Disaster and Its Deadly Wake*. The Asbury Park Library, housed in an impressive Bradley-era building, has a large collection of primary source material, including microfilm collections of the town's newspapers, and is a must visit for those interested in pursuing the city's history.

The authors also recommend that those whose interest in Asbury Park's past has been piqued by this book check out the Asbury Park Historical Society's website at http://www.asburyparkhistoricalsociety.org/index.htm. The historical society, dedicated to preserving the city's rich history and conserving and protecting its historical sites, sponsors events and sells books and memorabilia related to Asbury Park.

ABOUT THE AUTHORS

Joseph G. Bilby received his BA and MA degrees in history from Seton Hall University. He is assistant curator of the National Guard Militia Museum of New Jersey at Sea Girt and author of nine books on New Jersey and military history, including the recent History Press title *Sea Girt, New Jersey: A Brief History*.

Harry F. Ziegler received his BA in English from Monmouth University and his MEd from Georgian Court University. He is the former managing editor of the *Asbury Park Press* and is currently an honors English and journalism teacher, news magazine moderator and public relations officer at Bishop George Ahr High School in Edison, New Jersey.